THE CAR AND THE CAMERA

The Detroit School of Automotive Photography

David L. Lewis
and
Bill Rauhauser

THE DETROIT INSTITUTE OF ARTS

IN ASSOCIATION WITH

WAYNE STATE UNIVERSITY PRESS

This catalogue is published in conjunction with the exhibition
"The Car and the Camera: The Detroit School of Automotive Photography"
at the Detroit Institute of Arts, June 16-November 24, 1996.

Director of Publications: Julia P. Henshaw
Editor: Judith A. Ruskin
Editorial Assistant: Maria L. Santangelo

Distributed by Wayne State University Press
4809 Woodward Ave., Detroit, Michigan 48201-1309

LIBRARY OF CONGRESS
CATALOGING-IN-PUBLICATION DATA

Lewis, David Lanier, 1927–
 The car and the camera: the Detroit school of automotive
photography / David L. Lewis and Bill Rauhauser.
 p. cm.
 "This catalogue is published in conjunction with the exhibition
"The car and the camera: the Detroit school of automotive photography" at
the Detroit Institute of Arts, June 16-November 24, 1996"—Copyright p.
 Includes bibliographical references and index.
 ISBN 0-8143-2674-9
 1. Advertising photography—Michigan—Detroit—Exhibitions.
2. Photography of automobiles—Exhibitions. I. Rauhauser, Bill, 1918– .
II. Detroit Institute of Arts. III. Title.
TR690.4.L48 1996
779' .9629222—dc20 96-18693
 CIP

FRONT COVER: 1985 OR 1986 FORD MUSTANG GT

Ken Stidwill

"The Car and the Camera:
The Detroit School of
Automotive Photography"
was organized by
The Detroit Institute of Arts
and made possible by
Ford Motor Company,
with additional support from
the Michigan Council for Arts
and Cultural Affairs
and the DIA Founders Society.

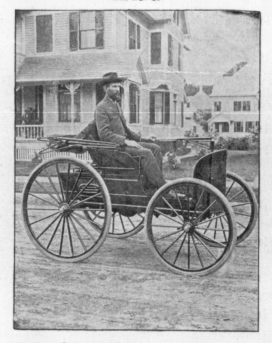

Duryea Motor Wagon Company,

SPRINGFIELD, MASS.,

MNFRS. OF

Motor Wagons, ——
Motors and . . .
Automobile Vehicles
—— of all kinds.

(FIG. 1) 1896 DURYEA

CONTENTS

In Celebration of 100 Years of Automotive Manufacturing

N 1996, NORTH AMERICAN automobile manufacturers are celebrating one hundred years of producing motor vehicles. With nearly 200 million cars, trucks, and other forms of motorized transportation logging close to 2.4 trillion miles on America's roads every year, the car companies have come a long way from their modest beginnings in 1896, when brothers Charles F. and J. Frank Duryea produced thirteen identical "motor wagons" in Springfield, Massachusetts (fig. 1).[1] The idea of producing vehicles in quantity quickly spread to the Midwest, where Henry Ford perfected mass production with his moving assembly line. As automotive production took root in Detroit, making it the world's Motor City, the area developed as the center for related fields of endeavor such as car photography, a phenomenon that came of age after World War II. Effective promotion of vehicle sales was paramount to the success of the auto industry, and photography became essential in putting forth the car company's message. A majority of the public probably saw the photographic image of a particular car well before seeing the actual model on the road or in a showroom.

With this exhibition, the Detroit Institute of Arts pays tribute to two technological developments that have radically altered life during this century: the car and the camera. The automobile has increased our independence and freedom of movement, created a huge job market, and raised our living standard, beginning with Henry Ford's five-dollar-a-day wage. It created a new roadside culture of service stations, motels, drive-in restaurants, and billboards. The car has filled us with dreams, fantasies, and illusions. The camera has influenced the very way in which we see the world. Susan Sontag, in her book *On Photography,* writes: "Instead of just recording reality, photographs have become the norm for the way things appear to us, thereby changing the very idea of reality."[2] Photography has extended our scientific frontiers, allowing us to see events that take place so rapidly or on so small a scale that they are invisible to the unaided eye. It has provided an aid to our memory and opened our minds to the wonders of art and beauty.

This exhibition presents these two great forces for change on a stage where they interact most intimately: automotive photography with eighty images by selected Detroit photographers, whose skills with the camera brought glory and glamour to the automobile beginning in the late 1940s. Exhibitions that consider the automo-

bile from the point of view of art are not unfamiliar occurences to Detroiters. This museum celebrated its own centennial in 1985 with the exhibition "Detroit Style: Automotive Form 1925–1950." However, the first exhibition anywhere to relate the automobile to art was organized in 1933 by the Detroit Society of Arts and Crafts. "Art in the Automobile Industry" was an attempt to credit designers for their accomplishments in the auto industry. In the same vein, the aim of the current exhibition is to examine photographs of cars as aesthetic objects.

Many people contributed their time and effort on behalf of this exhibition, but "The Car and the Camera" would never have been realized without the efforts of Bill Rauhauser, retired professor of photography at Detroit's Center for Creative Studies. He first proposed the idea for it to the museum's Department of Graphic Arts several years ago and has since performed countless hours of research, sought out individual photographers, and made many other contacts in the community in his quest to tell the story of Detroit's role in the creation of automotive photography. His catalogue essay describes the technical inventions and innovations that pushed Detroit to the forefront of the field. David Lewis, professor of business history at the University of Michigan, has contributed a thoughtful essay on the cultural implications of car advertising over the past century.

For their contributions to the exhibition and this publication, the museum would like to thank, first and foremost, all the photographers and lenders for their willingness to participate in these endeavors. The museum is also indebted to Mark Patrick, Curator of the National Automotive History Collection at the Detroit Public Library, for his assistance. Warm thanks are extended to Brian Obidzinski at Color Detroit, Larry Kinsel and John Robertson at GM Media Archives, Dan Erickson in Photo Media at the Ford Motor Company, and George Handley, Wally Sternicki, Keith Jolly, and Jim Secreto for sharing their knowledge and expertise.

Central to the realization of the project at the Detroit Institute of Arts has been the Department of Graphic Arts. Judith Ruskin, senior editor, and editorial assistant Maria Santangelo were responsible for editing and production of the catalogue, designed by Don Hammond. As always, there are many other staff members too numerous to mention who have given their best efforts as always to the completion of all of the work involved. My thanks go to them all.

Finally, the Ford Motor Company must be acknowledged for its interest in this project and the willingness to support it generously.

Samuel Sachs II
Director, The Detroit Institute of Arts

NOTES

1. Brock Yates, "An American Love Affair," *Life Magazine: Hot for the Road, 100 Years of the Automobile in America* (Winter 1996 Special Issue): 13.

2. Susan Sontag, *On Photography* (New York, 1977), 87.

THE DEVELOPMENT OF THE DETROIT SCHOOL OF AUTOMOTIVE PHOTOGRAPHY

Bill Rauhauser

FTEN OVERLOOKED in the history of photography is the emergence of the "car shooters" in Detroit from the 1950s through the 1970s, a period that coincides with the Golden Age of Advertising of 1945 to 1965. The innovative work of photographers such as Jimmy Northmore, Mickey McGuire, Warren O. Winstanley, Guy Morrison, Dennis Gripentrog, and Vern Hammarlund led Detroit to be regarded as the world center of automotive photography. However, their work has never received the same attention given other photographic genres, due in part to the legacy of Alfred Stieglitz, who strove to impose rigorous boundaries between artistic and commercial photography in the early years of this century. His hostile attitude toward the latter has been difficult to dispel.[1]

At the turn of the century, art photographers, known as Pictorialists, tried desperately to distance themselves from both professional photographers, working largely as portraitists, and amateur snapshooters in order to enhance their own status as true artists. Stieglitz organized the Photo-Secessionists, an elite group of photographers, to promote photography as a fine art by producing works with visual characteristics similar to painting. The resulting photographic style was characterized by subject matter presented in soft focus and by print processes that allowed for great manual manipulation of the image to achieve an idealistic rather than realistic effect. By about 1920, pictorialism had run its course and was succeeded by modernism, which drew its aesthetic from an urban and industrial environment. It encouraged a more pragmatic interpretation of the subjects encountered by artists, to be recorded as straight photographic images free of any handwork and captured as sharply as the camera lens was able. By the 1930s, Stieglitz had also abandoned pictorialism, but maintained his restrictive approach to photography as art, which he now defined "as a black and white, sharp focus print made with great deliberation in the name of art."[2]

The Photo-Secessionists broke up partly because some of the group's most important members—Edward Steichen, Clarence White, and Gertrude Käsebier—turned to commercial photography out of economic necessity. The advantage of straight photography to the advertising field was noted by John Tennant as early as 1919, in an issue of *Photo-Miniature.* In the article "Marketing Photographs for Advertisers," he wrote that straight photographs (which he referred to as modern photographs) can "awaken a keen sense of

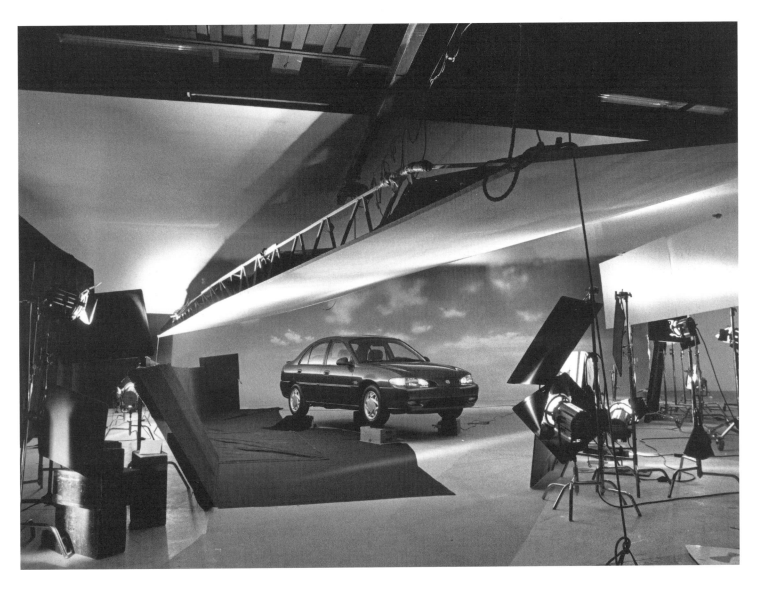

(FIGURE 2) A SHOOT IN PROGRESS

General view of Northlight Studios during a recent shoot by Guy Morrison. Photograph of studio by Bill Rauhauser.

possession." Photography started coming into its own in advertising after World War I and made substantial gains during the Depression, when straight photography was valued for its realism. [3]

While fashion photography and photojournalism have their roots in the early days of photographic history and have gained acceptance as artistic disciplines, automotive photography came into being much later and has not yet been given much consideration as an art form. Perhaps because the early fashion work of Edward Steichen and Baron De Meyer was done in the soft focus pictorial style then in vogue, it was more readily accepted as art. In automotive photography, one style did not dictate the approach to an image; rather the particular style was an option to be chosen depending on the needs of a given advertising campaign. Soft-focus or pictorialist effects were employed frequently to create atmospheric backgrounds in the 1950s, '60s, and '70s, particularly when an advertising campaign demanded a romantic tone (plate 9), but the automobile itself always remained in sharp focus. Although the images produced by the car photographers were realistic depictions, they were highly calculated and manipulated compositions.

By the second half of the twentieth century, there were significant changes in attitude about the nature of art in general and the distinction between high art and commercial art had blurred. The ability to define clearly the difference between art photography and commercial photography was no longer as simple as it had once appeared. The pop art movement of the early '60s in New York borrowed heavily from both commercial art and popular culture to produce such works as Andy Warhol's 1964 *Brillo Box*, Roy Lichtenstein's comic strip paintings, and James Rosenquist's *I Love You With My Ford* of 1961 (fig. 3). Such works helped reduce the stigma attached to commercial art. The highly detailed deep focus and brilliant colors of straight photography also seemed better

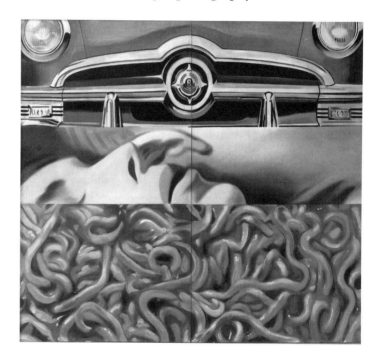

(FIGURE 3) I LOVE YOU WITH MY FORD

James Rosenquist, Moderna Museet, Stockholm, Sweden.
©1996 James Rosenquist/Licensed by VAGA, New York, N.Y.

attuned to contemporary tastes. The definition of art has become so broad that now it encompasses subjects previously scorned or ignored.

Until the end of World War II, most automotive advertising was done by graphic illustrators, whose medium of ink and color pigments allowed them the freedom to ignore unattractive lighting effects and unwanted reflections on car surfaces (see fig. 4). The artists could choose exotic settings and fill them with people and objects without worrying about the costs of actual props, models, and location. Nor were they restricted to the world of reality; they could render the cars' proportions to suit the latest trends. In the early '50s, automotive manufacturers followed the dictates of Harley J. Earl, vice president of styling for General Motors, and designed their cars "lower, longer, wider." [4] Illustrators could easily exaggerate this look in their renderings.

As early as 1932, photographer Anton Bruehl noted this preference for illustrations over photographs in automotive advertising. "An artist can lengthen a car out and make it look much more impressive. For that matter, so can a photographer; he could lengthen out a Ford until it looked like a Rolls-Royce. But the powers that be in the automobile field simply won't show a distorted photo. If one wheel is bigger than another someone will object to the picture." [5] The highly innovative work of Detroit photographers during the 1950s and '60s, however, advanced the ability to capture desired effects on film and allowed photography to supplant illustration in automotive advertising. Such shooting techniques as tent lighting; cove construction to eliminate the line where wall meets floor; motion mechanisms; liquid light; the use of various lenses, particularly anamorphic and wide-angle; and most importantly the ability to reproduce the stretch effect on film made a new look in automotive photography possible.

The demand for car photography grew as auto production soared following the end of World War II, and Detroit became not only the motor capital of the world, but the world center of automotive photography as well. A distinct Detroit Style emerged during this time, characterized by an emphasis on the cars themselves, or in the parlance of the photographers, "showing iron." When people were included, more often than not, they were unknown models hired through a talent agency. Their primary purpose was to function as an accessories to the cars, although some of the models, such as the youthful Tom Selleck amid sand dunes (plate 31) or Bo Derek posing as a prep-school student (plate 33), went on to greater fame. The Detroit photographers most often placed the models behind the cars, giving an unobstructed view of the vehicles. New York photographers, on the other hand, were more likely to place the models in front of the cars. The two arrangements became known as the "Detroit side" and "New York side," respectively.

The history of automotive photography in Detroit can be traced to about 1933 and the opening of the studio Photographic Illustration, Inc., at 6555 Oakland Avenue in Detroit, by Marshall Gorton and Michael Todd. Among their young photographers was Clifton Hartwell (plate 1), who went on to become one of the pioneers of Detroit automotive photography. Another early car shooter was Cleland Clark (plate 3), who did automotive photography for the advertising agency Brooke, Smith, and French, Inc., in Detroit, as early as 1940.

(FIGURE 4) PACKARD EIGHT

Graphic art, which was used exclusively to illustrate auto catalogs,
was replaced in the early 1950s by the innovative work of Detroit photographers.

During World War II, Hartwell and Clark were working for the government, photographing tanks and military hardware in the Oakland Avenue studio. Walter Farynk, who studied photojournalism at Columbia University in New York, also went to work at the studio. After the war, all three were hired by General Motors Photographic. Hartwell and Clark left after a few years, while Farynk remained for almost thirty years, becoming coordinator of creative photography for General Motors.

Several other photographers received their initial training while serving in the military. Warren O. Winstanley learned photography in the United States Office of Strategic Services during World War II. Dennis Gripentrog learned about motion pictures in the Army Signal Corps and did extensive filming for the United States Information Office in Korea. Vern Hammarlund was a Navy photographer during the Korean War.

In about 1947, Jimmy Northmore was hired by Art Greenwald of New Center Studio to take photographs for the drawings produced by the studio's graphic artists. Northmore was soon joined at New Center by Hartwell and Mickey McGuire. In 1954, Northmore and McGuire teamed up and bought New Center Photographic, a division of New Center Studio, and renamed it Boulevard Photographic, Inc. For the next twenty years it was the most active car studio in the world, building additional stages in London, Los Angeles, and Atlanta large enough to handle automobiles. Studio space was acquired in Düsseldorf, where a special stage was constructed to resemble the inside of an egg to accommodate the Volkswagen Beetle, which was difficult to light because of its shape. The London and Düsseldorf studios were known as Boulevard International. Northmore and McGuire had great influence on the field, for it was at their studios that many young photographers received their introduction to the art of shooting cars.

Some photographers worked independently of the studio system or formed their own businesses. These included Winstanley, who had apprenticed with Clark from 1948 through 1956, and Hammarlund, who began his career assisting at another studio in 1958 before opening his own in 1961. Guy Morrison, a native of Alabama who studied at Wayne State University in Detroit, was with Northmore and McGuire at New Center from 1952 until 1955, when he left to do fashion work in New York. He remained there until 1963, when he decided he did not like having to deal with buttons and stitches and returned to Detroit to photograph cars. He opened his own studio in 1964. Dennis Gripentrog, after studying photography at Brooks Institute of Photography in Santa Barbara, California, joined Bloomfield Photographic in 1958 and began assisting on car shoots. In 1961 he opened his own studio.

Many photographers of the succeeding generation trained at Boulevard, took classes from Farynk at Detroit's Center for Creative Studies, or a combination of both. Farynk began teaching studio photography part time in 1969, becoming a full-time professor after retiring from General Motors in 1974. Among those who studied with Farynk and are included in this exhibition are Tom Burkhart, who also studied at the University of Michigan, Ken Stidwill, Dennis Wiand, Peggy Day, and Tim Damon. After graduation, Burkhart assisted Gripentrog in 1974 and 1975 and Morrison in 1976. Burkhart, Keith Jolly, and Michael Conn purchased Morrison's studio in 1987 and renamed it Northlight Studios. Stidwill, after graduating, assisted Northmore and McGuire at Boulevard in the '70s, moving to DGM Studios in 1982. Both Day and Damon assisted at Boulevard after finishing their studies at the Center for Creative Studies. Day was the first woman to enter the field of car photography. Robert Traniello studied at the USAF Photo School in Denver, the New York Institute of Photography, and the Art Center College of Design in Los Angeles. He was with Boulevard from 1960 until 1986 and is now teaching at the Center for Creative Studies.

The field of automotive advertising opened to photography when the car shooters devised methods to stretch the length of a car visibly through photographic

means (plate 8) and worked out new, sophisticated lighting arrangements. To duplicate the long, low look that car illustrators achieved in their renderings, Northmore and McGuire improvised a special film holder that held the unexposed film in a curved position (fig. 5). The curved surface increased the length of the car only and did not affect its height. By positioning the camera with the holder in place either closer to or farther from the automobile, the image captured on the curved film surface could be made shorter or longer by almost any amount. The closer the camera was to the car, the greater the stretch. There was, however, a limit. If stretched too far, the car's normally round wheels began to take the shape of footballs, although the distortion could be corrected by photographing the wheels separately and stripping them onto the final print. Also, the car had to be lined up perfectly on the lens axis to prevent it from becoming banana shaped. Focusing the image on the curved film surface to achieve overall sharpness presented further difficulties, but with care could be accomplished.

An alternative method of achieving the stretch effect was to use a curved easel in printing, a laborious darkroom operation that took control away from the photographer. Instead of capturing the image on a curved film, the regularly exposed film was printed on a curved photographic easel, which gave the finished image the same elongated look as produced with the special film holder. Another means of adding to the extra low look of cars was to load sandbags in the trunk and under the hood or place blocks of wood to hold the car's suspension in compression.

To preserve the advantages of achieving the stretch look with their special film holder for themselves and to prevent advertising agency representatives from taking the idea to other photographers, Northmore and McGuire resorted to a subterfuge. By mounting two free turning knobs on the film holder, they implied that more or less stretch was being controlled by an extremely complex mechanism. Overall, secrecy took on great importance in the competitive auto industry and the studios went to great lengths to keep the cars under wraps and away from prying eyes. General Motors took its own photographs to avoid the possibility of disclosure of new models. Among the photographic studios, separate stages and locations were used for the various manufacturers.

In 1953 the motion picture industry introduced CinemaScope, an early wide screen projection system, which achieved its panoramic effect through an optical system developed in France by Henri Chrétien in 1928. Northmore and McGuire realized the advantage of using such an anamorphic system, which could produce compressed or expanded images, and abandoned their curved film holder after the mid-1950s. With a prismatic-type anamorphic optical system mounted on the 8 by 10 inch studio camera, beams of light reflected from the cars were spread apart horizontally as they traveled through a pair of adjustable prisms to reach the camera lens. The relationship between the two prisms could be altered to produce varying amounts of stretch.[6] Photographers were now able to exaggerate the long, low look of automobiles with increased speed and ease.

Other lenses could produce different effects. Warren O. Winstanley made innovative use of the spherical Hypergon lens, which encompasses a field of view of 135 degrees. With its small aperture, it produces a dramatic picture with objects in sharp focus from just a few feet in front of the lens to those a great distance away (plate 23). Wide-angle lenses were also used to dramatize the grillwork on cars, accentuating the front end housing the engine and suggesting its horsepower (plate 25).

Truth-in-advertising campaigns and the gradual shift to smaller cars, hastened by the oil embargo of the early '70s, eventually discouraged the kind of exaggeration found in automotive photographs. Federal law governing unfair and deceptive commercial practices stipulates, among other things, that the product must be shown in advertisements exactly as the customer buys it and that strange camera angles to make the product appear other than it is must be avoided. In 1957, Vance Packard's *The Hidden Persuaders* had been published and aroused a storm of protest against Madison Avenue. The advertising industry was accused of resorting to the use of subliminal messages in television commercials and motion picture productions to influence viewers' buying habits. The public began to insist on honesty in advertising.[7]

The very nature of automobile design also began to change, making the longer, lower look less desirable. The year 1959 marked the height of the craze for tail fins, loads of chrome, and excessive length. Cars began to shrink from that point on with such compact models as the Ford Falcon, the Chevrolet Corvair, and the Plymouth Valiant joining a growing list of small imports.[8]

Other methods were employed to enhance the look of cars in photographs.

Any car photography, whether done outdoors in direct sunlight or indoors in the studio, produces harsh reflections and deep shadows if not controlled with special

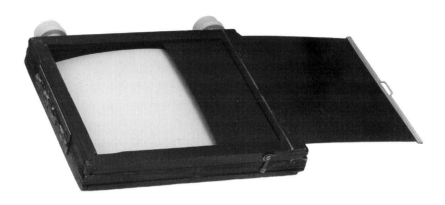

(FIGURE 5) FILM HOLDER

This device, invented by Boulevard Photographic, held unexposed film on a curved surface rather than a flat plane, allowing the photographer to lengthen the image of a car. Photo by Bill Rauhauser.

screens, tents, and other devices. In the early days, when shooting was done in a studio setting, the lighting was of a theatrical nature, using huge spotlights and floods. This often resulted in an uneven effect because the light from the spots was difficult to control. In addition, when color film replaced black and white, the car's chrome parts had a disconcerting habit of reflecting the blue of the sky or any other color nearby. This was particularly problematic with chrome parts, which art directors

The black flat in the foreground prevents unwanted light from reflecting on the body of the car.

insisted should appear white. To solve this problem photographers resorted to an adaptation of a lighting system used for years to photograph silverware and other highly reflective objects, known as tent lighting.

The first application of tent lighting in Detroit was Northmore's photographs of a 1950 Mercury (plate 2) made on the stage of the Music Hall, rented to provide a space large enough to handle the car and lighting setup since none of the existing photographic studios was large enough. A tent—consisting of four white walls, two of

solid material and two of white muslin, covered with a large muslin sheet suspended above the car—was built on the stage with banks of lights located over the top of the fabric roof. A small opening was provided in one of the side muslin sheets for the camera. The result was a soft, diffused light that allowed unwanted reflections to be eliminated with ease, especially on chrome parts, which now appeared white. The light could be further controlled by strategically placing large black sheets wherever needed on the studio floor and walls to shape contours and provide modeling effects by reflecting dark tones off the car's body (fig. 6).

Studio space eventually grew to barnlike proportions to accommodate the new lighting systems and the stages could eventually house an eighteen-wheel semitrailer. Winstanley, underscoring photographers' ability to take advantage of unique opportunities, accepted an offer to use the sets and lots of Hollywood's Universal Studio for his work. He was even given an office on the grounds. These huge spaces allowed him to experiment with many different stagings and backgrounds (plate 29).

In time, the tent arrangement was replaced by a large white flat mounted over the car, which would then be illuminated from light bounced off the flat (see fig. 2). The flat could be tilted on its axis to any angle desired, thus allowing greater control in directing the light. Through the placement of white reflectors and black flats, photographers could emphasize the sculptural shape of the car body. For example, a large black cloth on the floor would produce a dark area on the side of a car below the molding. Vertical black flats placed alongside the

car prevented unwanted light from reaching the surface and creating highlights. The use of lights, reflectors, and neutral density or colored gels placed in front of the lights carefully controlled the location, intensity, and color of reflections. The preparation and lighting of the automobile for a photograph often required days of time, while the actual camera exposure may have lasted only two or three minutes.

Lighting techniques were originally designed to reveal the sculpted shape of the car body (plate 25), but they also can be used simply to produce highlights independent of the metal's shape, resulting in a kind of "liquid light" effect (plate 19). The light does not outline any particular part of the vehicle but rather independently flows over it.

To add scenic views to the studio setting, a system of front projection (again borrowed from the motion picture industry) was used to add appropriate backgrounds to the setups (plates 5, 6). Transparencies of the desired landscape or city scene were projected onto a large screen (often forty feet or longer) placed behind the car, thus transplanting the Grand Canyon or the Eiffel Tower to the studio with ease. Trees, bushes, sand, and other accoutrements were brought indoors to fill in the foreground. While photographing in the studio had many obvious advantages—no concern over weather conditions, no expensive transportation of cars, support personnel and equipment, and no need to protect the car from the eyes of the competition while out in public —it was costly, requiring special projectors, highly reflective screens, and difficult lighting techniques. The

(FIGURE 7) CHRYSLER CORPORATION VEHICLES

Figures 7 and 8 illustrate the use of digital retouching to alter a photographic image. Photo by Dennis Wiand.

indoor system was used primarily by Farynk of General Motors Photographic but was too expensive and impractical to be widely used.

Despite the advantages of shooting indoors, often a real outdoor setting was desired. Photographing at sunrise or sunset with the sun just below the horizon produced a wonderful highlight effect on automobile surfaces referred to as "sweet light" (plate 18, 44). The

work had to be done quickly, however, due to the rapidly changing light conditions. Palm Springs, California, was used extensively in this context because the sun setting behind the mountains extended the useful glow time from a few seconds to an hour or more. San Francisco was suggested as a location by Northmore and promoted by Fred Peck, a creative art director with Grant Advertising, to take advantage of the fog, which

(FIGURE 8) DIGITAL ALTERATION OF FIGURE 7

The mountain range has been removed to emphasize the vehicles.

provided a perfect simulation of tent lighting. This was first used in a 1956 Dodge catalog.

Dramatic outdoor lighting effects could also be achieved through the use of special filters. McGuire adapted the use of neutral density gels, filters made of gelatin film exposed or dyed to match a particular density of gray, for such work. The gels, graded from top to bottom so as to underexpose only the sky, were placed a short distance in front of the camera lens. The resulting images strikingly isolate the car from the background. Winstanley would often accentuate the vehicle through the use of large black mesh screens placed between the car to be photographed and the background scene (plates 28, 29). This diffused and reduced the light intensity of the background and placed the main emphasis on the car.

A problem for the car shooters, both inside the studio and out, was how to photograph a stationary vehicle yet give it the illusion of movement. A particularly sophisticated solution was developed by Northmore, who devised a hydraulic motor rig that allowed the photographer to make an automobile appear to be traveling at a high rate of speed while actually sitting in a studio (plate 19). He constructed a system of hydraulic cylinders that moved the car and the camera in unison in front of a fixed background. By adjusting the camera's shutter to give a time exposure in seconds or minutes rather than the customary fraction of a second, different rates of speed could be simulated. A similar system was often used to imply motion outdoors using a slightly different technique in which the scenery moved instead of the car. A background was built on the platform of a flatbed truck, which was then driven past a stationary car. A time exposure blurred the background image and gave the appearance of motion to the car. Tim Damon developed a variation on methods for capturing the illusion of motion with his outrigger, a device allowing a camera to be mounted on a cantilever extending from the car. As with the earlier Northmore rig, the camera moves at the same speed as the car to give the sense of movement (plate 55). The simplest method of achieving motion, however, was to smear a glass plate placed a few inches in front of the lens with petroleum jelly. This technique required great skill in applying the jelly, for the wrong amount or location on the glass plate could create an indistinct haze, but when done properly, the exposed film was blurred in such a way as to produce a dramatic sense of movement. Multiple exposures could also be used to suggest motion (plate 22). At times numerous methods were used simultaneously.

Not all automotive photography actually appeared in advertisements. Some photographs were used to present concepts or ideas for possible ad campaigns or to demonstrate the capabilities of the studio. The creative compositions and innovations found in much automotive photography, however, resulted from the give and take between photographers and art directors. The final images, in many ways, represent a team effort involving photographers, art directors, set fabricators, and support personnel. During the early decades of the industry, photographers exercised more artistic license and creative control than they do today. Often unforeseen situations encountered on location required innovation, and the alteration of original plans and the input of photographers was encouraged by art directors seeking solutions to the problems. In such cases the technical expertise and creative energies of the photographer together with talented art directors who were willing to take risks and encourage innovation resulted in a period that can be referred to as the Golden Age of Automotive Photography. Over time, however, control has passed increasingly to art directors, who manage tight budgets. They represent the advertising agencies and oversee all aspects of the shoot—the design of sets and the selection of sites, props, models, and wardrobes.

Just as photography replaced graphic illustration in the late '50s and early '60s as the medium of choice in automotive advertising, electronic imaging now threat-

ens to replace much of traditional silver-based photography. In traditional photography, silver halide crystals in the film emulsion are converted to metallic silver when exposed to light and developed chemically. With electronic imaging, cameras employ solid-state chips to measure and record light by an electronic process rather than a chemical one. The personal computer replaces the darkroom of conventional photography. Images are imported from the digital camera, stored on the computer's hard drive, and displayed on the monitor, where the photographer or art editor can manipulate the picture. By this process the image can be altered to a degree unimagined by traditional photographic retouch-ers. The computer offers the total freedom to alter color, change perspective, add or delete desired background effects, remove unwanted details from the original image, simulate motion, blur the image, or change highlights and shadows (figs. 7, 8).[9]

By the turn of the century electronic systems will, in all probability, be equal in quality and economy to the present silver systems. The last fifty years have witnessed the growth of a rich tradition in automotive photography, but the latest developments in visual imaging are moving the creative manipulation and control of picture making from the studio stage to the computer screen.

NOTES

1. Robert A. Sobieszek, *The Art of Persuasion* (New York, 1988), 96. For more on art and commercial photograpy, see Michele H. Bogart, "The Rise of Photography," chapter 4 in *Artists, Advertising, and the Borders of Art* (Chicago, 1995), 171-204.

2. Bonnie Yochelson, *New York to Hollywood: The Photography of Karl Struss* (Fort Worth: Amon Carter Museum, exh. cat., 1995), 133.

3. Tennant quoted in Bonnie Yochelson, "Clarence H. White Reconsidered: An Alternative to the Modernist Aesthetic of Straight Photography," *Visual Communication* 8, 4 (Fall, 1983); and Bogart 1995 (note 1), 199-201.

4. Pat Chappell, *The Fabulous Fifties* (Iola, Wisc., 1992), 6.

5. Quoted in Robert S. Mann, "Anton Bruehl Sees Advance in Photography," *The Commercial Photographer* 7, 7 (April 1932): 265. This reference was brought to the author's attention by Kathleen Erwin.

6. Arthur Cox, *Photographic Optics,* 15th ed. (London and New York, 1974), 309.

7. Kenneth Roman and Jane Maas, *The New How to Advertise,* (New York, 1992), 139; and Vance Packard, *The Hidden Persuaders* (New York, 1957).

8. Nick Georgano, *The American Automobile: A Centenary, 1893-1993* (New York, 1992), 204.

9. Mikkel Aaland and Rudolph Burger, *Digital Photography* (New York, 1992).

Status, Sex, Speed: the Selling of the American Automobile

David L. Lewis

IMAGES OF AUTOMOBILES and car advertising have been barometers of social and cultural tastes, morals, and mores since the advent of the horseless carriage a century ago. Some images depict, indeed reflect, mainstream values of their era. Even more portray an idealized view of life. For nearly one hundred years, automobile manufacturers have been pushing the car as a means of attaining improved social standing, new levels of speed and comfort in traveling, and romantic moments. Starting in the 1920s, an era of burgeoning car ownership and road building, advertisements increasingly linked the motorcar with greater freedom, adventure, sightseeing, escape, motoring for motoring's sake, the song of the open road, and, as phrased two decades earlier by Henry Ford, "God's great open spaces." These themes are illustrated throughout the Detroit Institute of Arts' exhibition "The Car and the Camera: The Detroit School of Automotive Photography" in images taken from the 1950s through the 1990s.

The first auto advertisements sought to convince the public that cars were readily available with a wide range of desirable qualities. The first illustrated auto ad, published in the inaugural issue of *The Horseless Age* (November 1895) (fig. 9), used a photograph of a three-quarters view of an 1895 Racine, with copy promising "speed, safety, comfort, and economy." In the same issue, Duryea Motor Wagon Works shunned images and employed only text to promote its product; the company's first illustrated ad did not appear until six months later.

Although trade papers published the first auto ads, general publications such as *Cosmopolitan*, *Scribner's*, and *Harper's* soon followed suit. By 1905 automakers were spending $1 million annually on advertising, half of which went to the twelve leading general magazines. Oldsmobile and Winton set the pace, each with annual ad budgets of $100,000. These early ads and those following through the 1940s usually relied on drawings to illustrate the cars. [1]

Sex appeal, initially tied to masculine virility, was a staple of auto imagery from the earliest years. A 1911 Pierce-Arrow ad mentioned neither price nor anything else about the car (fig. 10). Such sophisticated images were targeted at males, although they no doubt appealed to women as well. This eventually gave way to images of pert "girls" at the wheel or glamorous women decorating a car. In addition to enticing female consumers, the ads seem to say to men: women love this car: drive it and attract them. Reminiscent of this genre in the exhibit is

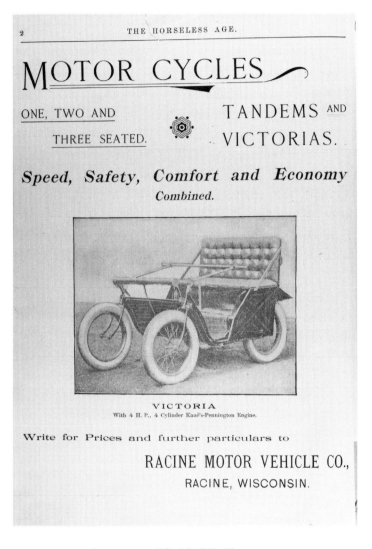

MOTOR CYCLES

ONE, TWO AND
THREE SEATED.

TANDEMS AND
VICTORIAS.

Speed, Safety, Comfort and Economy
Combined.

VICTORIA
With 4 H. P., 4 Cylinder Kauf's-Pennington Engine.

Write for Prices and further particulars to

RACINE MOTOR VEHICLE CO.,
RACINE, WISCONSIN.

(FIGURE 9) 1895 RACINE

*The first American auto ad featured many
of the same selling points used today.*

Vern Hammarlund's image of a 1968 Chevrolet Impala convertible and its male driver being admired by eight pretty surfers, some demure, some playful, some seductive, all hoping for a ride (plate 17). Other images using sex appeal to sell cars include Walter Farynk's images of a woman standing behind a long-hooded 1958 Corvette (plate 7) and of a beach scene in which a lifeguard and three female bathers admire a 1955 Chevrolet Bel Air convertible (plate 5). Glamorous and seductive women continue to decorate auto ads, although perhaps because of the women's movement, a little less breathlessly than in the past.

The first of the classic automotive advertising images —featuring a dramatic illustration of an Oldsmobile racing a train—appeared in 1910 (fig. 11). As they plunged ahead in grand fury, car and locomotive were juxtaposed, showing the former speeding on a road set below the railway embankment. The image quickly became the world's best known piece of automotive art. Reproductions were hung on the walls of countless social, motoring, yachting, and athletic club rooms, as well as in Olds dealerships. Cars in motion, or the illusion thereof, a staple of auto imagery since the days of dust and exhaust fumes, are represented in the exhibit by the play on lights and illusion of speed and motion in Walter Farynk's image of a 1966 Buick Rivera (plate 14), which seems to be spewing flame as it blasts off, and by Boulevard's images of a 1968 Jaguar in motion (plate 19); a 1968 Corvette Stingray with triplicated taillights; and a head-on view of a 1969 Stingray trailed by the shadow of a second and third vehicle (plate 22).

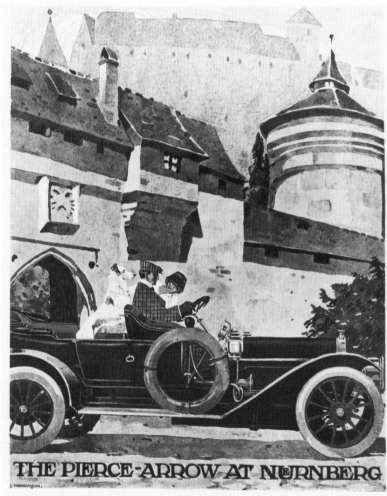

THE PIERCE-ARROW AT NURNBERG

The highest accomplishment of the Pierce-Arrow car is found in its availability for restful, comfortable and satisfactory long distance tours.

THE PIERCE-ARROW MOTOR CAR COMPANY, BUFFALO, N. Y.
In Paris at 22 Avenue de la Grande Armee

(FIGURE 10) 1911 PIERCE-ARROW

Emphasizing the car's prestige and snob appeal, this ad mentions neither price nor anything else about the car. In 1909 two Pierce-Arrows were selected for the White House auto fleet.

Ironically, one of the greatest auto ads, Cadillac's 1915 "The Penalty of Leadership," eschewed art except for a small reproduction of the automaker's "Standard of the World" emblem (see figure 12). The page-long text only once mentioned Cadillac by name, and simply observed that:

> the reward for leadership is widespread recognition; the punishment fierce denial and detraction. When a man's work becomes a standard for the whole world, it also becomes a target for the shafts of the nervous few. If his work be merely mediocre, he will be left severely alone—if he achieves a masterpiece, it will set a million tongues a wagging…If the leader truly leads, he remains—the leader. Master-poet, master-painter, master-workman, each in his turn is assailed, and each holds his laurels through the ages. That which is good or great makes itself known, no matter how loud the clamor of denial. That which deserves to live—lives.

Following the ad's appearance in the *Saturday Evening Post* (January 2, 1915), "Penalty of Leadership" generated hundreds of thousands of requests for copies. Translated into numerous foreign languages, analyzed by countless marketing students, the ad found its way onto the walls and desks of numerous self-styled leaders. In a 1945 readership survey conducted by *Printer's Ink,* a journalists' trade publication, the ad was voted the greatest of all time. Fourteen years later it was cited in Julian Lewis Watkins' book, *The 100 Greatest Advertisements*, as "perhaps the greatest of all advertisements." [2]

The first ad campaign to romanticize the automobile and represent it as a ticket to fun and adventure appeared in 1923. "Somewhere West of Laramie," (fig. 13) one of a series of similarly themed ads, was written by Ned Jordan to promote the Jordan car company's Playboy model. "Laramie" ran a sketch of a young woman, scarf flying, racing a Playboy roadster past a hat-waving cowboy astride a galloping horse. The lyrical text, when combined with the illustration, aimed to convince countless female college students and flappers that the Playboy was the car of their dreams. Among young males the comparable car was the Stutz Bearcat which, more than any other auto, was identified with the devil-may-care playboys of the dashing decade that began just before America entered World War I. [3] The text proclaimed:

> Somewhere west of Laramie, there's a bronco-busting, steer-roping girl who knows what I'm talking about. She can tell what a sassy pony, that's a cross between greased lighting and the place where it hits, can do with eleven hundred pounds of steel and action when he's going high, wide and handsome. The truth is—the Playboy was built for her....Step into the Playboy when the hour grows dull with things gone dead and stale. Then start for the land of real living with the spirit of the lass who rides lean and rangy, into the red horizon of a Wyoming twilight.

The Playboy ads revolutionized automotive advertising, which, according to *Automobile Quarterly*'s Tim Howley, "became more emotional, rhetorical, illogical, wildly explicit, but irresistibly flattering." [4] During the

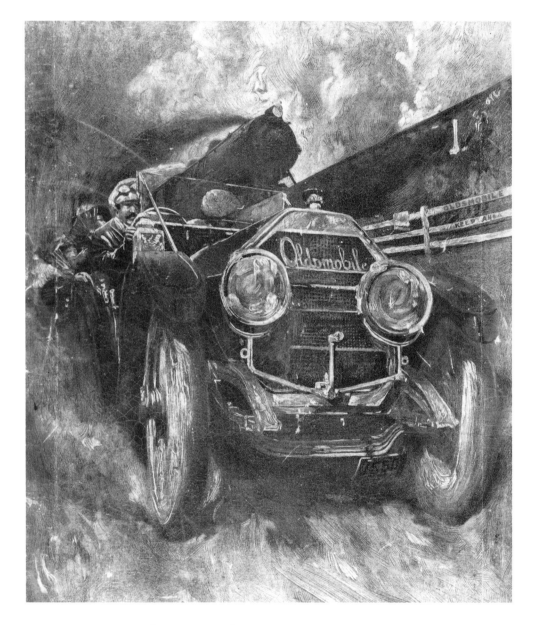

(FIGURE 11) RACING THE LIMITED

The 1910 Oldsmobile Limited was one of the most immense and powerful cars of its day.
Auto enthusiasts would have put money on the Olds in a race against any train.

remainder of the 1920s and into the 1930s many auto images linked cars with romance, adventure, and the end of the rainbow. Jordan, the man who had started it all, was deluged with letters from women. Among those caught up in the "Laramie" spirit was an Ohioan who wrote, "Dear Mr. Jordan: I do not want a position with your company. I just want to meet the man who wrote that advertisement. I am 23 years of age, a brunette, weigh 120 pounds, and my wings are spread. All you've got to do is to say the word and I'll fly to you."[5] The "Laramie" ad has enduring appeal, and is better known today than the car it promoted. In 1996 *Automotive News*, noting that the ad initiated "a new era of image advertising," added that it is "considered by many to be the best car ad ever."[6] A lineal descendant of Playboy ads is Boulevard Photographic's exciting montage of a young horsewoman astride a charger that surprisingly dominates the 1968 Oldsmobile 88 it challenges (plate 20).

The automobile has continually been touted as an avenue to freedom, adventure, and romance. Boulevard Photographic placed cars in rustic settings—a horse farm or an apple orchard, while Walter Farynk constructed a studio set to resemble a beach (plate 5). Romantic moments were made complete by the inclusion of a car in the atmospheric scene. Couples meet and embrace in close proximity to an automobile in Boulevard's shots of a 1959 Buick Electra, a 1960 Buick Invicta (plate 9), and a 1968 Thunderbird (plate 18), and in Guy Morrison's photograph of a 1972 Thunderbird (plate 30). The call of the open road still beckons in Warren O. Winstanley's image of a 1969 Opel on an overlook of Rio de Janeiro,

its harbor, and Sugarloaf Mountain (plate 23); Ken Stidwill's image of a 1985 or 1986 Mustang GT convertible on a mountain road bathed in golden light (cover); Thomas A. Burkhart's overhead images of a 1989 Buick winding along a lonely, curving highway (plate 45) and of a Jeep pictured on the edge of a lighthouse promontory (plate 46); and Dennis Wiand's Jeep in a spectacular desert setting (plate 51).

The advent of all-terrain vehicles has redefined the notion of a drive through the countryside to encompass rugged, off-road adventures. Stidwell's Jeep in a forest (plate 40) underscores this notion that a vehicle can take people to isolated, out-of-the way locations regardless of the terrain. The wanderlust examples by Burkhart, Wiand, and Winstanley provided an unusual approach to auto advertising, since the car appears as a tiny object in comparison to the surrounding landscape. The location or destination is stressed over the car itself judging by the amount of space each occupies, but the point is not lost that it is the vehicle itself that makes such travel possible.

Some advertising campaigns were aimed specifically at women, who drove in increasing numbers as the self-starter was popularized in the 'teens and as single women gained more economic and social independence in the 1920s. With such headlines as "Freedom for the Woman Who Owns a Ford," artwork and ads typically showed females driving alone on mountain roads or through the countryside, picking up a child at a nursery school, or phoning from an office as the occupant's car, seen through a window, awaits outside. In later images,

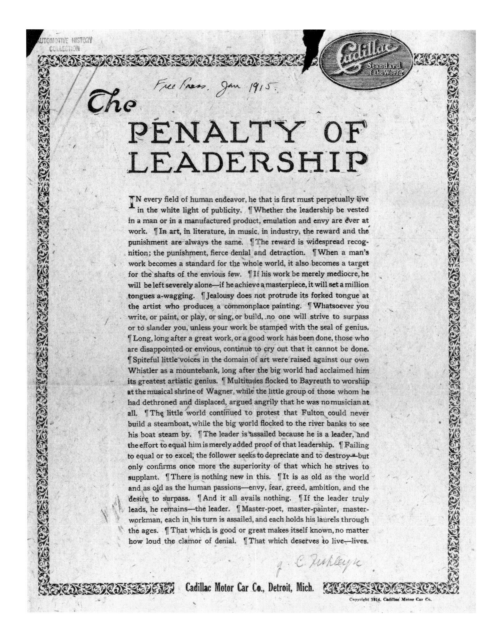

Free Press. Jan 1915.

The PENALTY OF LEADERSHIP

IN every field of human endeavor, he that is first must perpetually live in the white light of publicity. ¶ Whether the leadership be vested in a man or in a manufactured product, emulation and envy are ever at work. ¶ In art, in literature, in music, in industry, the reward and the punishment are always the same. ¶ The reward is widespread recognition; the punishment, fierce denial and detraction. ¶ When a man's work becomes a standard for the whole world, it also becomes a target for the shafts of the envious few. ¶ If his work be merely mediocre, he will be left severely alone—if he achieve a masterpiece, it will set a million tongues a-wagging. ¶ Jealousy does not protrude its forked tongue at the artist who produces a commonplace painting. ¶ Whatsoever you write, or paint, or play, or sing, or build, no one will strive to surpass or to slander you, unless your work be stamped with the seal of genius. ¶ Long, long after a great work, or a good work has been done, those who are disappointed or envious, continue to cry out that it cannot be done. ¶ Spiteful little voices in the domain of art were raised against our own Whistler as a mountebank, long after the big world had acclaimed him its greatest artistic genius. ¶ Multitudes flocked to Bayreuth to worship at the musical shrine of Wagner, while the little group of those whom he had dethroned and displaced, argued angrily that he was no musician at all. ¶ The little world continued to protest that Fulton could never build a steamboat, while the big world flocked to the river banks to see his boat steam by. ¶ The leader is assailed because he is a leader, and the effort to equal him is merely added proof of that leadership. ¶ Failing to equal or to excel, the follower seeks to depreciate and to destroy—but only confirms once more the superiority of that which he strives to supplant. ¶ There is nothing new in this. ¶ It is as old as the world and as old as the human passions—envy, fear, greed, ambition, and the desire to surpass. ¶ And it all avails nothing. ¶ If the leader truly leads, he remains—the leader. ¶ Master-poet, master-painter, master-workman, each in his turn is assailed, and each holds his laurels through the ages. ¶ That which is good or great makes itself known, no matter how loud the clamor of denial. ¶ That which deserves to live—lives.

Cadillac Motor Car Co., Detroit, Mich.

(FIGURE 12) THE PENALTY OF LEADERSHIP

Created by Theodore F. MacManus of MacManus, John & Adams, Detroit,
this ad, remarkable for its simplicity, has the reputation as the greatest of auto ads.

Cleland Clark's 1952 Packard convertible features a stylishly dressed woman behind the wheel (plate 3). Boulevard's 1961 Plymouth Fury shows a woman who had driven her car along the beach and is chatting with an off-duty lifeguard (plate 10). Dennis Gripentrog's 1974 Mercury Monterey appears as the vehicle of choice of a mother and her teenage daughter seen on the grounds of what could be an upscale private school (plate 33).

The Classic Age of Motoring—the late 1920s and the early 1930s—produced classic images for the era's luxury cars. Indeed, the understated, soft-sell sketches, watercolors, and paintings of the period were as regal as the motorcars and settings they promoted. Pierce-Arrow, Cadillac, Lincoln, and Duesenberg typically provided a view of chauffeur-driven limousines as seen through the full windows of a room in which sophisticated young women were at tea or an office in which a businessman dictated a letter. Other representative prestige ads showed a sketchily drawn tall, stylish woman striding down a boulevard graced by the car or a woman speaking to a friend as the latter's car pauses on a charming ivy-covered country bridge with a reflection of the woman and the car's spare tire appearing in the water below. Duesenberg, maker of America's most elite car, even disdained color and, at times, an image of the vehicle itself. Its ads simply showed patrician figures in commanding roles—a yachtsman at the helm, a woman in top hat and riding habit—accompanied by the haughty phrase "He (She) drives a Duesenberg." Such images seemed to say, "If you wish to associate with us, you will need this car."

Auto images usually have upscale, even swank, settings. Terraces, courtyards, winding driveways, horse farms, and proximity to cabin cruisers are in. Inner cities, working farms, and blue-collar subdivisions are out. Hartwell's photograph of a 1950 Hudson Custom Commodore convertible parked next to a wooden cabin cruiser suggests a luxious vacation ahead for the car's owners, who are seen boarding the boat (plate 1). Boulevard constructed elaborate sets featuring elegant terraces inhabited by models dressed in formal evening clothes (plate 8). Among other snob-appeal images are Dennis Gripentrog's shots of a gold 1974 Mercury Montego MX parked at the Hôtel des Invalides in Paris (plate 32) and a 1979 Cadillac Seville Elegante before the Manhattan skyline (plate 35). Peggy Day's depiction of a 1994 Acura set in a classical courtyard and draped with transparent veils seems a contemporary extension of these prestige-based ads (plate 52).

Not all ads were intended to appeal to status seekers. One of the most enduring auto images from the 1930s was an illustration for Everyman's car, the Chevrolet. Highway billboards showed a Chevy and an all-American family—Dad at the wheel, Mom by his side, and two kids and a mutt in the backseat—under the title, "World's Highest Standard of Living" and the line, "There's no way like the American Way." The realities of the 1930s and the Great Depression, however, failed to jibe with the ad's idealized view of American life (see figure 14). Such discrepancies between images and reality have continued to permeate auto advertising. Until the 1970s, despite changing demographics, auto ads generally fea-

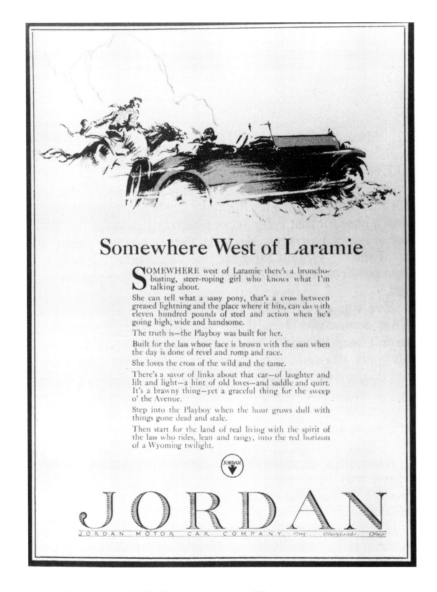

(FIGURE 13) SOMEWHERE WEST OF LARAMIE

Ned Jordan's poetic ads, aimed primarily at women, left an indelible imprint on auto advertising. The idea for this ad came to Jordan as he traveled west in his private railroad car. Observing a stunningly beautiful horsewoman racing alongside the train, he asked a companion where they were. "Oh, somewhere west of Laramie," came the reply.

tured white, suburban "all-American" families. In the exhibit the theme is exemplified by Boulevard Photographic's image of a 1960 Dodge Polara in the driveway of an attractive house, husband and housewife bidding adieu, and by Vern Hammarlund's image of a 1971 Cutlass in front of a suburban home complete with husband, wife, son, shaggy dog, and sycamore trees (plate 27). In recent years ethnically diverse families and groups increasingly appear in middle-class settings. Also, minivans and sports utilities vehicles supplement cars and station wagons in idealized surroundings.

There was no product advertising during World War II, when passenger-car production ceased. Institutional ads touted defense work and, toward the end of the war, the promise of postwar cars. The most memorable of the latter campaigns featured the slogan, "There's a Ford in Your Future" and illustrations of the idyllic postwar scenes superimposed on a crystal ball.

In the 1950s, the launchpad of the Detroit school of automotive photographers, advertising, newspapers, magazines, books, radio, and television extolled America and the good life. Not that puffery was needed, for most Americans innately believed in their country's goodness and greatness. They also were resolutely optimistic, and with reason. The United States was the world's leading military and economic power. Gasoline was plentiful and inexpensive. Homes, offices, and cars were often left unlocked. Detroit, fueled by the prospering automobile industry, had the highest rate of home ownership of any big city in the nation. The polio vaccine and the Pill were introduced, and eradication of the common cold and cancer seemed only a matter of time. Cholesterol concerns were nil, the ozone was mostly pure, sunshine was considered healthful, and smoking not particularly unhealthful. Theaters were huge and drive-ins plentiful. Commercial jets were introduced, and the space age beckoned. Boulevard's depiction of a 1956 Ford Fairlane in a circus atmosphere, complete with clown perched on the trunk, seems to reflect the optimistic, idealist, and perhaps naive, attitudes about life in the 1950s.

The 1950s were good years for the domestic auto industry, which retained nearly 90 percent of its home market. Rebounding after World War II, the auto industry enjoyed a seller's market until 1948. The Korean War of the early 1950s restricted civilian production, but in 1955 the industry sold a record 7,920,186 cars, a figure unsurpassed until 1965. Motorists routinely received full service at gasoline stations and, although enmeshed in city traffic and bound to two-lane cross-country roads, anticipated improvements with the building of the Interstate Highway System. Similarly, travelers were heartened by the Howard Johnson and Holiday Inn motels and McDonald's drive-ins sprouting up in place of mom-and-pop motels and roadside greasy spoons. There was a fatalistic acceptance of the almost 50,000 traffic fatalities per year. The American Dream seemed real, at least if you were white, middle class, and male. America—the very word had a splendid ring— was God's country, and most Americans firmly believed that no other land was half so well endowed or wonderful. Boulevard captured the essence of this American abundance in the images of a 1954 Packard Pacific

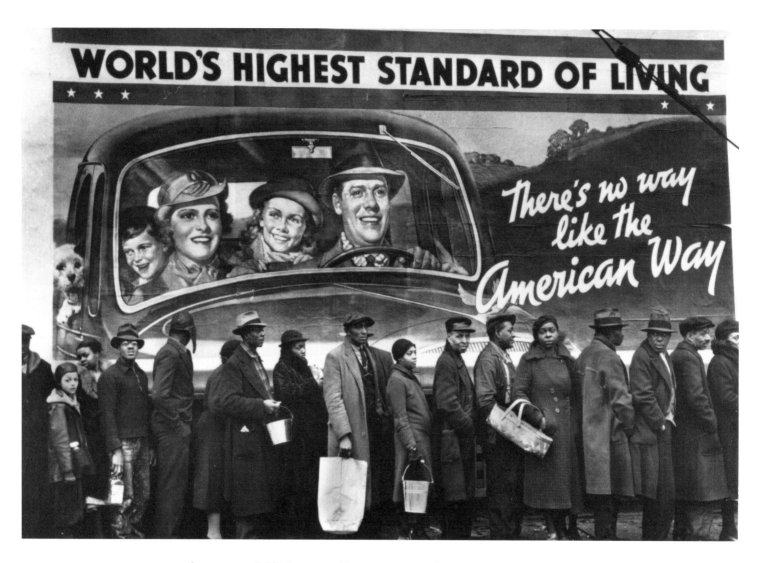

(FIGURE 14) AT THE TIME OF THE LOUISVILLE FLOOD

Extolling the world's highest standard of living, the American way, and Chevrolet, a billboard serves as a backdrop for Margaret Bourke-White's 1937 photo of Ohio River flood victims seeking support from a relief agency. The image symbolizes the flip side of the American Dream, which auto ads continued to portray throughout the Great Depression. Photo by Margaret Bourke-White, Life Magazine © Time Inc.

(plate 4) and a Packard Caribbean showing the car with models attired as cowboys and oilmen set against a backdrop painted by René Bouché, the chief illustrator for *Vogue* magazine in the 1950s.

The auto industry and its vehicles mirrored and helped shape the era. Cars of the 1950s, sporting powerful engines, monstrous tail fins, three-tone paint, wraparound windshields, and as much as forty-four pounds of chrome, were regarded by some as exemplars of the decade's excesses. Auto ads focused on styling and horsepower, plus the concept of planned obsolescence— the idea that last year's model was passé. A mere glance at the new model's tail fins rendered its immediate predecessor's appendages as old hat. Chrysler Corporation, the most conservative of stylists since it had been burned by its overly streamlined 1934 Airflows, went whole hog in 1957, replacing its undistinguished lineup with "Forward Look" styling that won numerous awards.

Automakers also sought to make cars appear to be personal expressions of owners' psyches as motivational psychologists asserted that purchasers equated their cars with mistresses, workhorses, weapons, trophies, or bait for sexual conquest. Convertibles were perceived as mistresses, sedans as the home and living room, and hardtops as the best of both worlds. As sex symbols, according to psychologist Dr. Joyce Brothers, cars to many men are "an extension of themselves and a powerful symbol of masculinity and virility. The more immature the male, the more his sexuality is apt to be linked to...cars. In their minds, there is a link between horsepower and sexual prowess. They may also equate driving with

sexual function which leads to the assumption that the bigger the car the better." Herbert Hoffman, director of a New York guidance center, maintained that man's hidden sexual fantasies may be determined by the kind of car he wishes to own. Thus those who want jazzy sports cars have fantasies involving sexually aggressive females; those wishing to own luxury cars dream of romantic affairs in exotic surroundings; would-be owners of four-wheel-drive vehicles are admirers of healthy women with well-developed bodies and physical endurance and dream of making love in scenic spots; and one-of-a-kind custom car fanciers have sexual fantasies in which they lead the life of a playboy, having more affairs than any other man on earth.[7]

A Social Research, Inc., study quoted by Vance Packard in *The Hidden Persuaders* expands on the premise that the automobile tells who we are and what we think we want to be. As summed up by a 1950s Buick promise, "It makes you feel like the man you are." Social Research's major finding holds that cars are heavily laden with social meanings and are highly esteemed because they "provide avenues for the expression...of the character, temperament and self concept of the owner and driver." For example, people who want other people to know their status, while expressing it modestly, may engage in deliberate downgrading. "They show their superiority by displaying indifference to status—by purposely buying less expensive cars than might be expected."[8] Today's counterparts tend to buy trucks—pickups and sports utilities, many of which haul only passengers and have never been off the pavement.

The 1960s and 1970s were a time of turmoil in this country, marked by many changes in society. Civil rights strife and the Vietnam War divided the country. School desegregation and busing accelerated white flight to the suburbs. Crime and drug abuse became national issues. Foreign competition decimated entire industries and threatened the bellwether auto industry. The American Century and the American Dream became jaded, and Americans no longer seemed to walk in seven-league boots. Still, auto ads continued to reflect traditional feel-good themes—romance, adventure, speed, and prestige. Not untypically, a 1967 Plymouth GTX ad, entitled "Goldilocks and the Three Bears" and picturing a provocative blonde, suggested that the car is a "very tempting bowl of porridge," that Goldilocks is "a highly adventuresome type of female," and that the GTX is strictly for the "Move over honey, and let a man drive" set. A 1969 Dodge ad, entitled "Mother Warned Me" and portraying a scantily clad blonde, adds "that there would be men like you driving cars like that. Do you really think you can get to me with that long, low, tough machine you just rolled up in?… My name's Julia."

No automaker rolled with the counterculture. But starting in 1959 Doyle Dane Bernback created a memorable, long-running campaign that poked fun at the Volkswagen Beetle, and helped it become a highly successful cult car. The campaign, built on selling a single advantage of the vehicle, made humor acceptable, flattered the reader that he or she was intelligent enough to learn by implication without having every point spelled out, and involved him in the dialogue with the advertiser. All ads were in black and white. One simply shows a head-on view of the Bug, the title, "Ugly is only skin deep," and the copy reads "It may not be much to look at. But beneath that humble exterior beats an air cooled engine. It won't boil over and ruin your piston rings. It won't freeze over and ruin your life. It's in the back of the car for better traction in snow and sand. And it will give you about 29 miles to a gallon of gas." Other ads typically showed an egg with the title, "Some shapes are hard to improve on"; a car floating on water entitled "Volkswagen's unique construction keeps moisture out"; and a painted body captioned, "After we paint the car, we paint the paint."

The muscle cars of the 1960s and early '70s were among the last gasps of autodom's golden age. The emphasis on horsepower is captured in Vern Hammarlund's image of a 1970 Oldsmobile Toronado, dramatically lit and exaggerated through the use of a wide-angle lens (plate 25). There are no props or models in the photograph, placing it among those advertisements that focused on the car alone. But Ralph Nader's book *Unsafe at Any Speed* focused attention on auto safety, and for the first time the auto industry was faced with federal regulation of vehicle safety design, exhaust emissions, and fuel efficiency. Japanese automakers made ever deeper inroads into the domestic market. The unthinkable finally occurred: America's love affair with the auto evolved into a love-hate relationship. During the 1970s, gas shortages and soaring prices at the pumps accelerated the move to smaller, more fuel-efficient cars. Photographers, finding it difficult to glamorize or romanticize compacts and

subcompacts, much less make them appear powerful or fast, occasionally set apart econoboxes with offbeat images, such as in Guy Morrison's placement of a white Dodge Omni in an untamed Western scene complete with valley and mountains, a foreboding sky, and a wind-bent tree (plate 36). Throughout the 1970s new-car prices outpaced inflation, producing sticker shock in consumers, and Americans purchased imported cars in greater numbers, believing they offered better quality and greater fuel economy than American vehicles. The U.S. auto industry went into a decline that did not level off until the mid-1980s.

The car shooters—white, middle-class, overwhelmingly male, and mostly midwestern, like the people for whom they worked—also were constrained by the society of which they were a part. All models, for instance, were white, generically white, and capable of blending into a middle- or upper-class setting. People of color, except for the occasional Native American or African American serving as a prop, were virtually invisible, as they were in all of advertising. On occasion, African American models might be featured, such as in Dennis Gripentrog's 1979 Cadillac Seville Elegante parked in front of a street vendor's cart and set against the Manhattan skyline (plate 35). It is another example of the good life, the only difference being that the couple enjoying New York City life are not white. White models even were used for ads sent to African American publications. Automotive images thus depicted a dream world of dream machines driven by white people who were variously carefree, fun-seeking, healthy, wholesome, handsome or

pretty, sensuous, cool, elegant, and sophisticated. As in the past, no model in this middle-to-upper class world was likely to be confused with a bus or subway rider, a grandparent, or a trucker. As the 1970s gave way to the 1980s and 1990s, however, auto ads began to look more like America, at least in terms of skin color. Minivans are filled with a rainbow of Cub Scouts, Brownies, and kids' sports teams (plate 49). Still, only professional-looking adults and freshly-scrubbed middle-class kids need apply. Poor folks remain unseen, as do the handicapped and the elderly, except as kindly grandparents used as props.

Some of the Detroit school's most imaginative, arresting, provocative images have no counterparts in the history of automotive advertising. Unrelated to a specific lifestyle or selling point, they ask consumers to draw their own conclusions. Chrysler promised a sense of mystery in its 1977 ad campaign "The Night Belongs to Charger." The ads featured a sleek Dodge Charger prowling the rain-slicked streets of an indistinct urban nightscape, whose lights twinkle and cast a greenish glow across the sky (plate 34). The openly suggestive text read "If your pulse quickens after dark, Charger is your car. Charger has a look that was shaped for the night. An excitement to match your mood when you've left the day behind. Close yourself in Charger, and the dark lights up....When the sun goes down and the lights come up, move into Charger time. Some of us were born for the night. Now we have a car that belongs to us." The text combined with the image leaves the exact meaning of the ad open to interpretation.

Among other such photographs are Walter Farynk's image of a 1967 Buick LeSabre with a mod woman pointing at something unknown (plate 15); Dennis Gripentrog's image of a 1968 Pontiac GTO with an elegant, tough blonde at its side and a 1930ish caricature of a feminine face serving as a backdrop (plate 21); Boulevard's image of a spooky scene with a 1970 Ford Torino and two hip models standing on a desolate stretch of beach (plate 24); Peggy Day's image of a mid-1980s Corvette parked before a canvas "forest" held in place by two maidens in nondescript dress (plate 43); and

Robert Traniello's image of six 1986 Toyotas parked on a sunbaked desert facing a late evening sunset (plate 44). These elusive images qualify as art, but primarily they were intended to sell cars.

Of the Detroit school of automotive photographers' images, it may be said, as has been said of cars, they don't make 'em like that anymore. And they probably won't again. Despite changes in photographic technology and automotive design, advertising probably will continue to hold up an idealized mirror to society, reflecting dreams and hopes rather than reality.

NOTES

1. Rudolph E. Anderson, *The Story of the American Automobile* (Washington, D.C., 1950), 274.

2. Julian Lewis Watkins, *The 100 Greatest Advertisements: Who Wrote Them and What They Did* (New York, 1959), 23.

3. Ralph Stein, *The American Automobile* (New York, 1971), 210.

4. Julia Pettifer and Nigel Turner, *Automania: Man and the Motorcar* (Boston, 1984), 130.

5. Watkins 1959, (note 2) 51.

6. "Reserve Your Space in History," *Automotive News*, Jan. 8, 1996.

7. Charles Goodrum and Helen Dalrymple, *Advertising in America: The First 200 Years* (New York, 1990), 242; and David L. Lewis and Lawrence Goldstein, *The Automobile and American Culture* (Ann Arbor, 1983), 127-128.

8. Vance Packard, *Hidden Persuaders* (New York, 1955), 52-54.

Facing Page: Roland Barthes, *Mythologies,* 1957, quoted in Kirk Varnedoe and Adam Gopnik, *High and Low: Modern Art and Popular Culture* (New York: Museum of Modern Art, exh. cat., 1990), 318.

PLATES

I THINK THAT CARS TODAY
ARE ALMOST EXACTLY THE EQUIVALENT
OF THE GREAT GOTHIC CATHEDRALS:
I MEAN THE SUPREME CREATION OF AN
ERA, CONCEIVED WITH PASSION BY
UNKNOWN ARTISTS, AND CONSUMED IN
IMAGE IF NOT IN USAGE BY A WHOLE
POPULATION WHICH APPROPRIATES
IN THEM A WHOLLY MAGICAL OBJECT.

Roland Barthes
1957

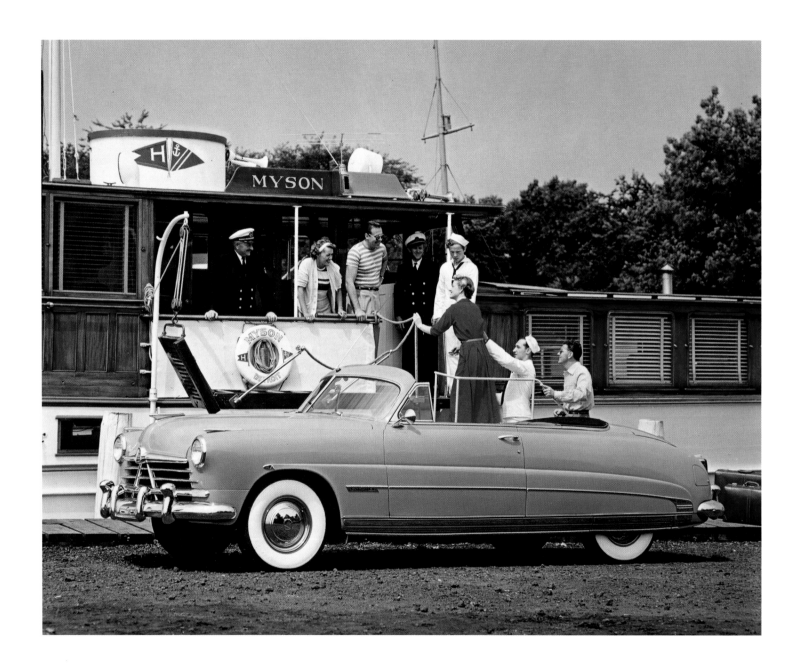

(1) 1950 HUDSON CUSTOM COMMODORE SERIES CONVERTIBLE BROUGHAM

Clifton Hartwell

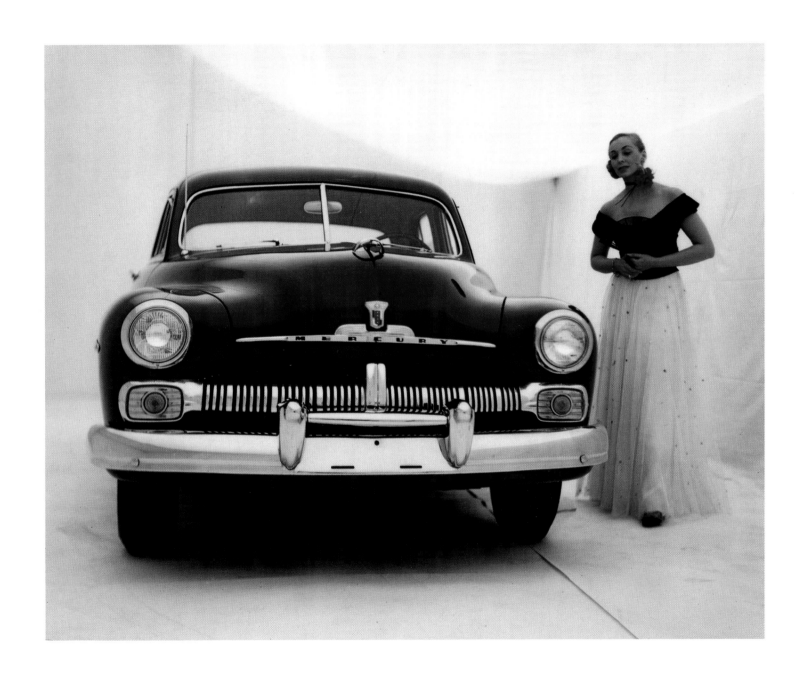

(2) 1950 Mercury

Jimmy Northmore

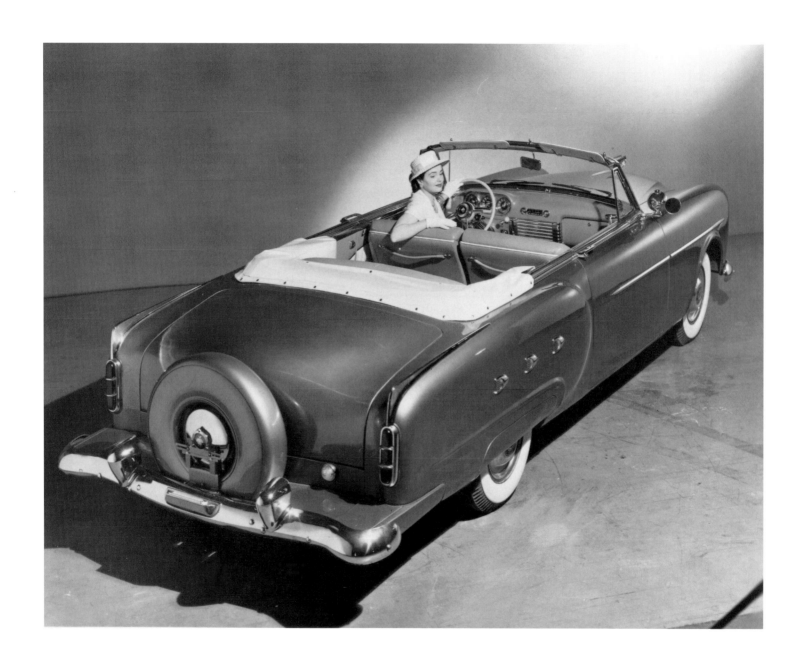

(3) 1952 Packard 200

Cleland Clark

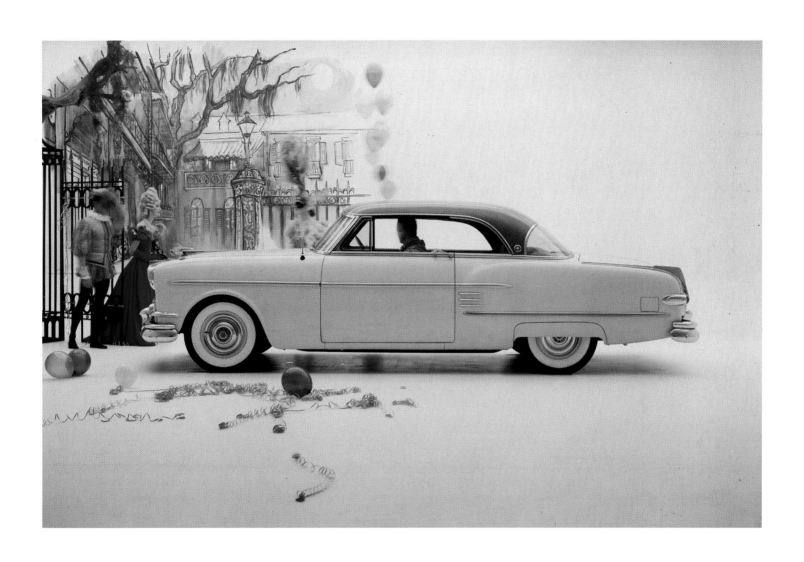

(4) 1954 PACKARD PACIFIC

Mickey McGuire and Jimmy Northmore, Boulevard Photographic, Inc.

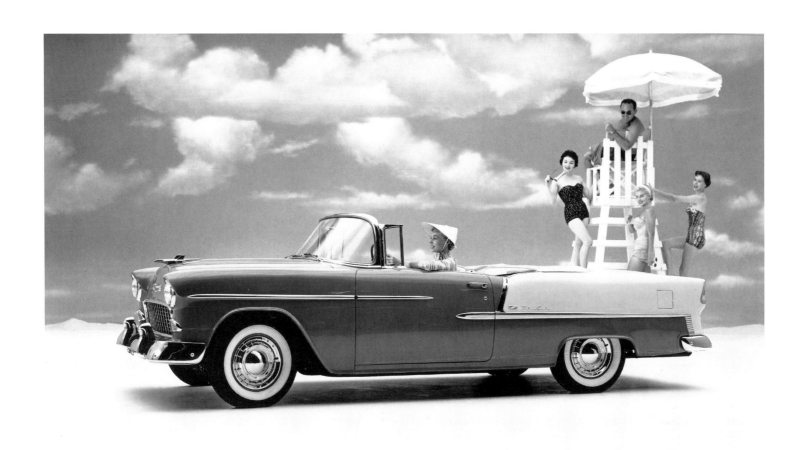

(5) 1955 CHEVROLET BEL AIR

Walter Farynk

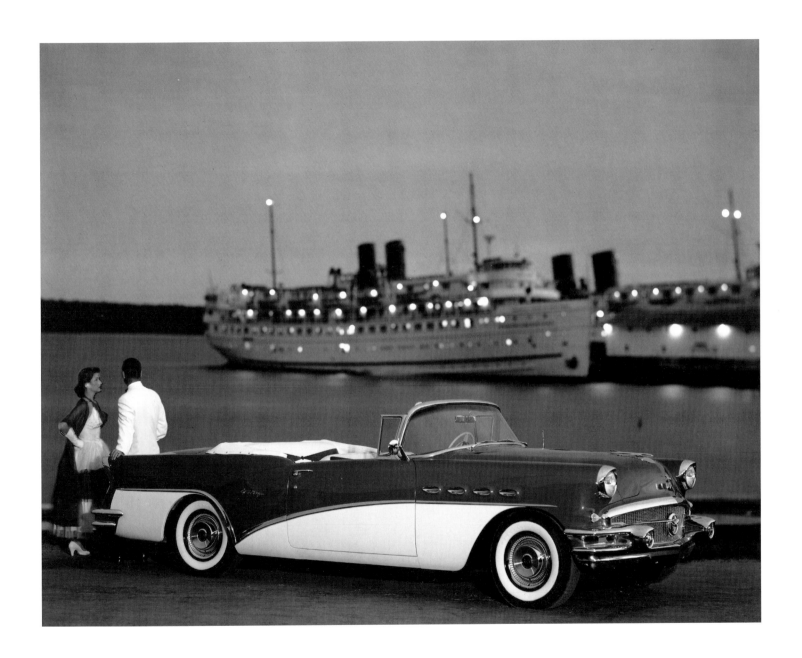

(6) 1956 BUICK CENTURY

Walter Farynk

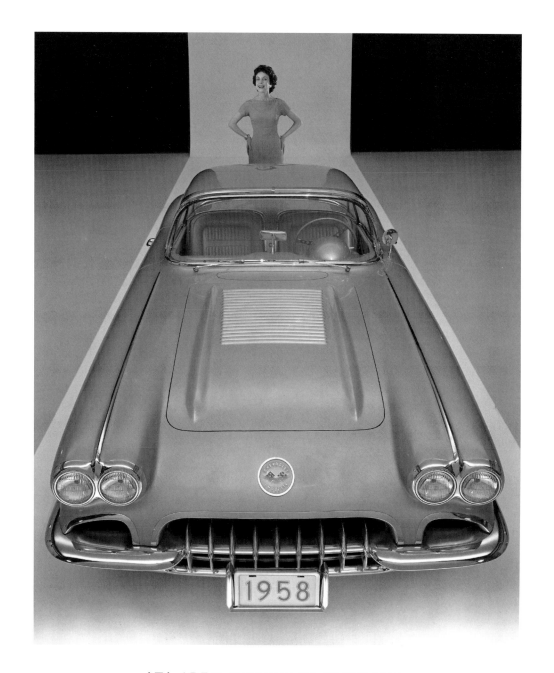

(7) 1958 CHEVROLET CORVETTE

Walter Farynk

(8) 1959 Lincoln Continental

Mickey McGuire and Jimmy Northmore, Boulevard Photographic, Inc.

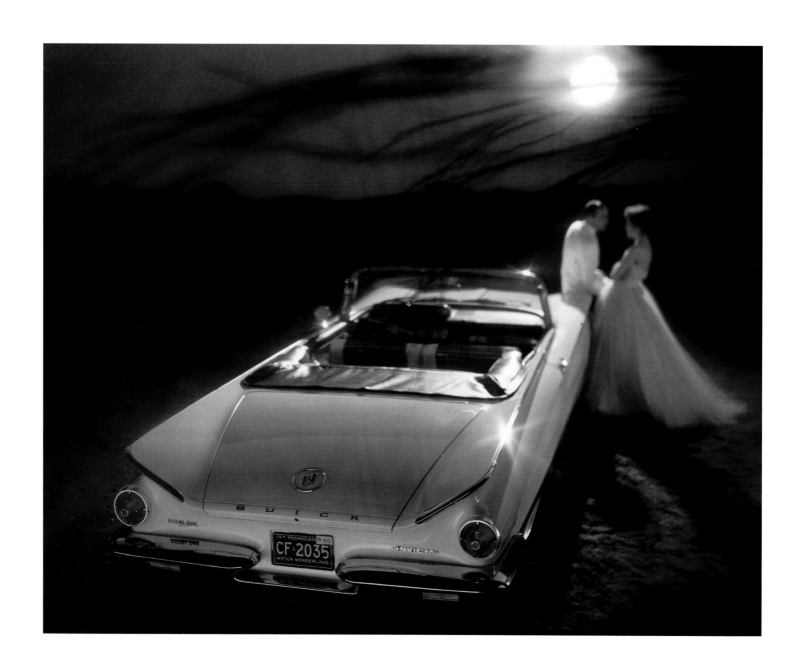

(9) 1960 Buick Invicta

Mickey McGuire and Jimmy Northmore, Boulevard Photographic, Inc.

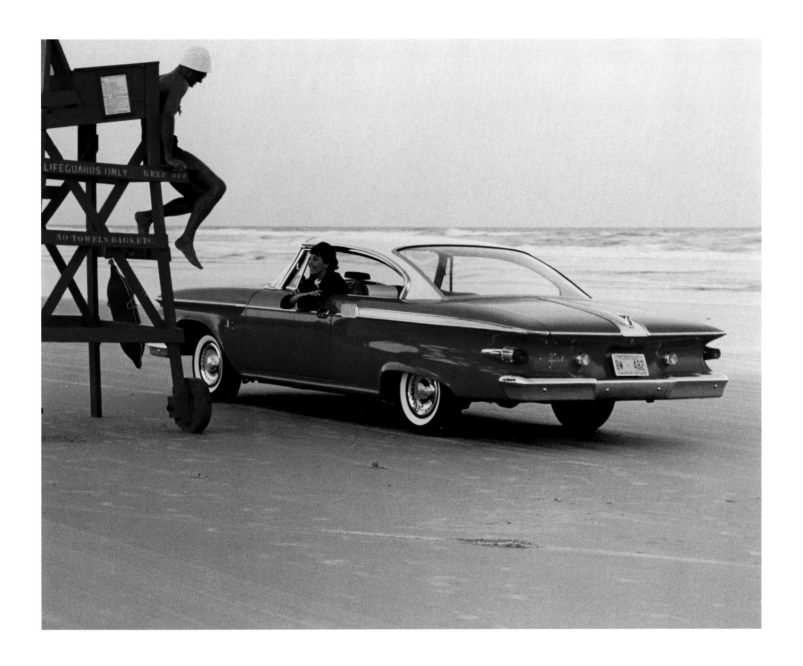

(10) 1961 Plymouth Fury

Mickey McGuire and Jimmy Northmore, Boulevard Photographic, Inc.

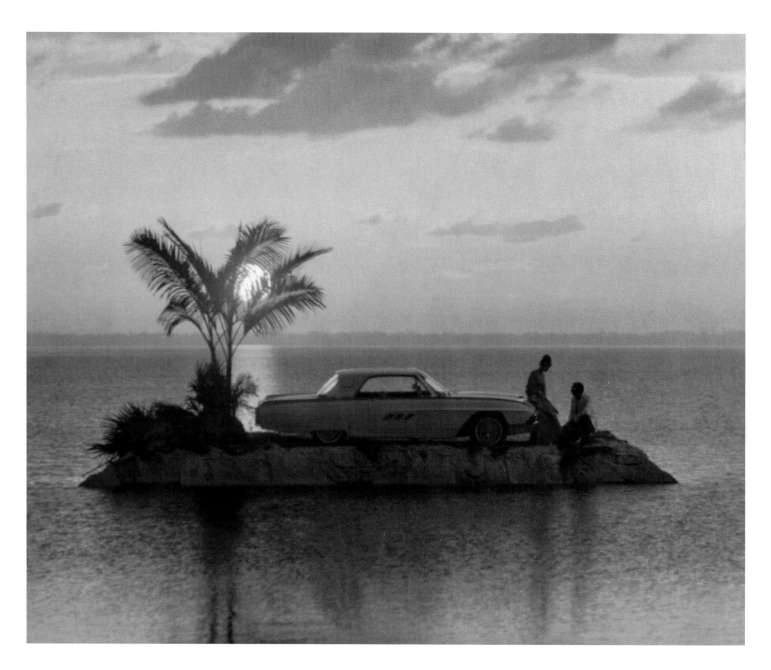

(11) 1963 Ford thunderbird

Mickey McGuire and Jimmy Northmore, Boulevard Photographic, Inc.

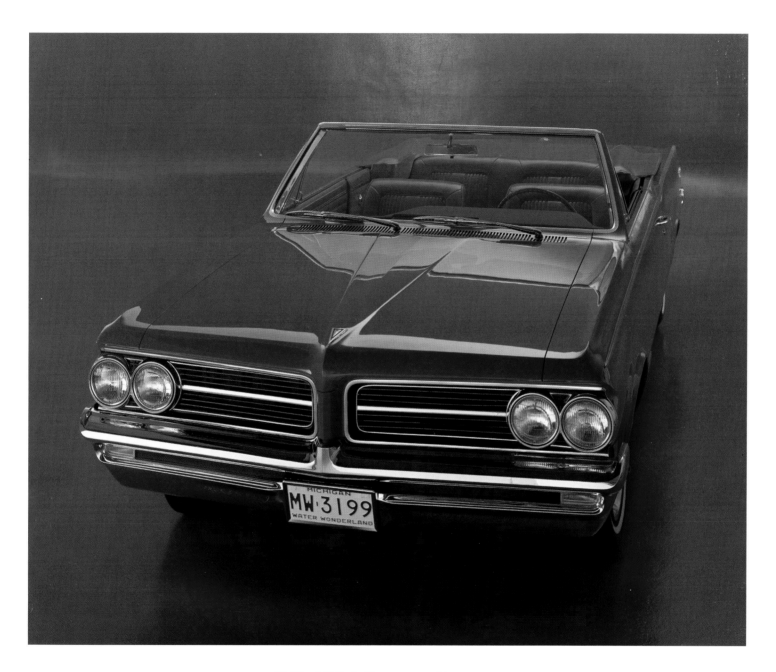

(12) 1964 Pontiac Tempest

Vern Hammarlund

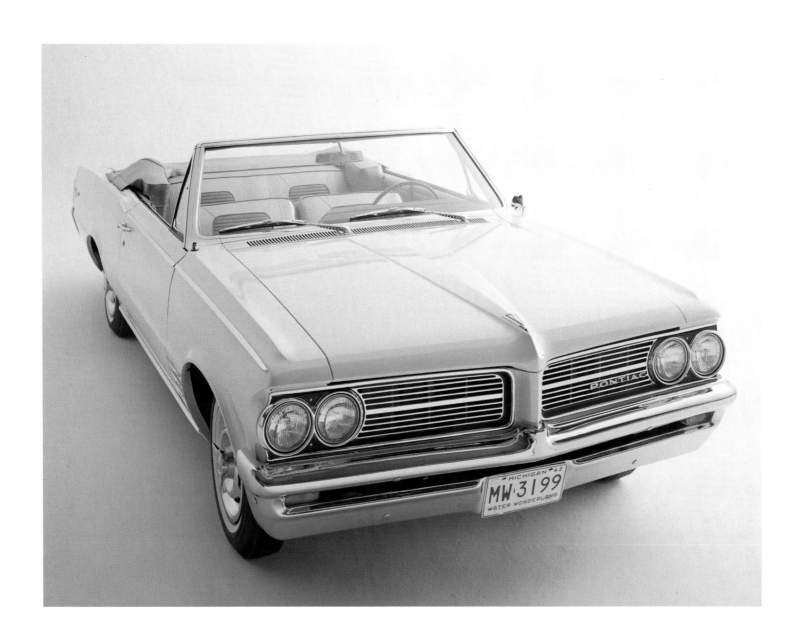

(13) 1964 Pontiac Tempest

Vern Hammarlund

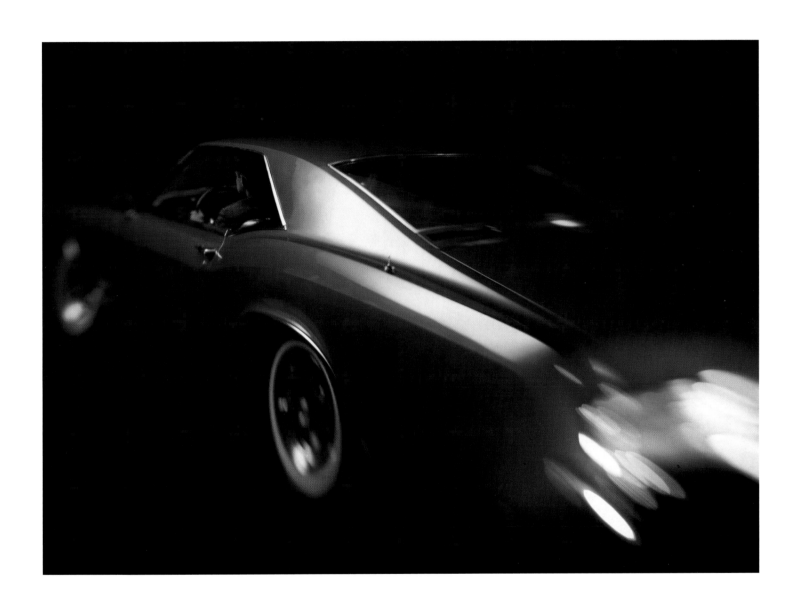

(14) 1966 Buick Riviera

Walter Farynk

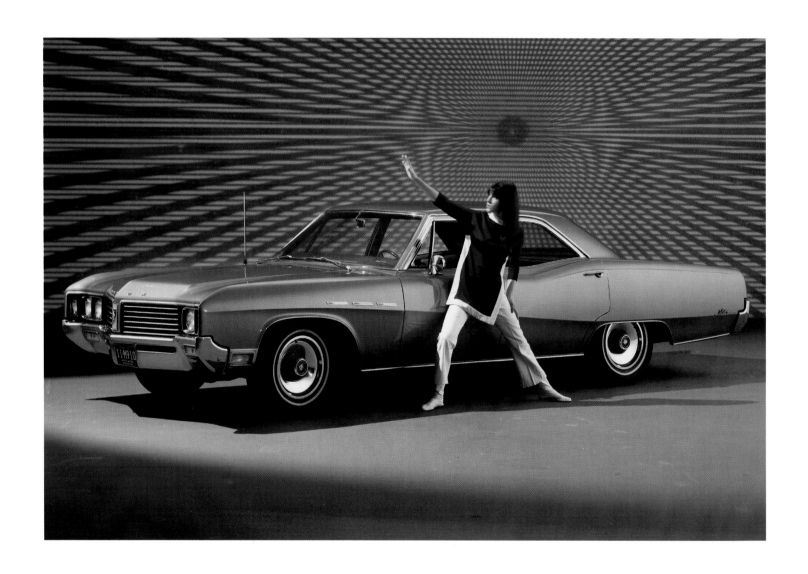

(15) 1967 Buick LeSabre

Walter Farynk

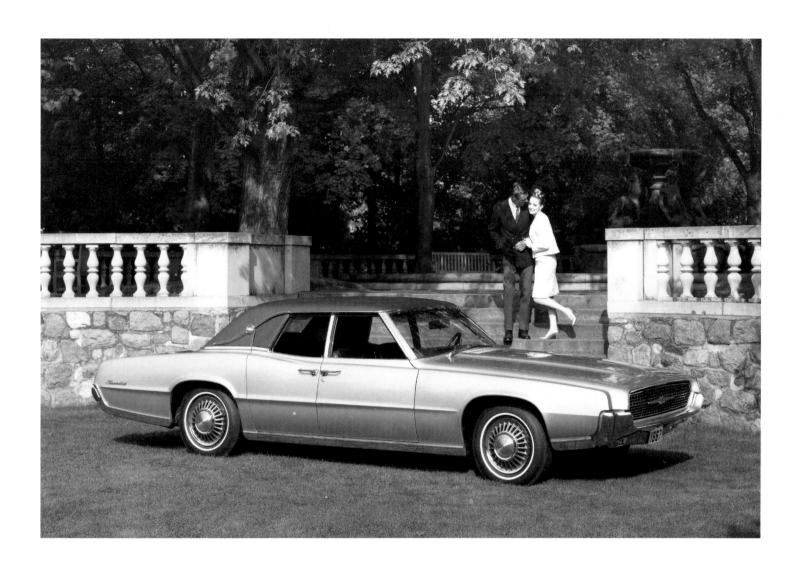

(16) 1967 Ford Thunderbird

Robert Borum

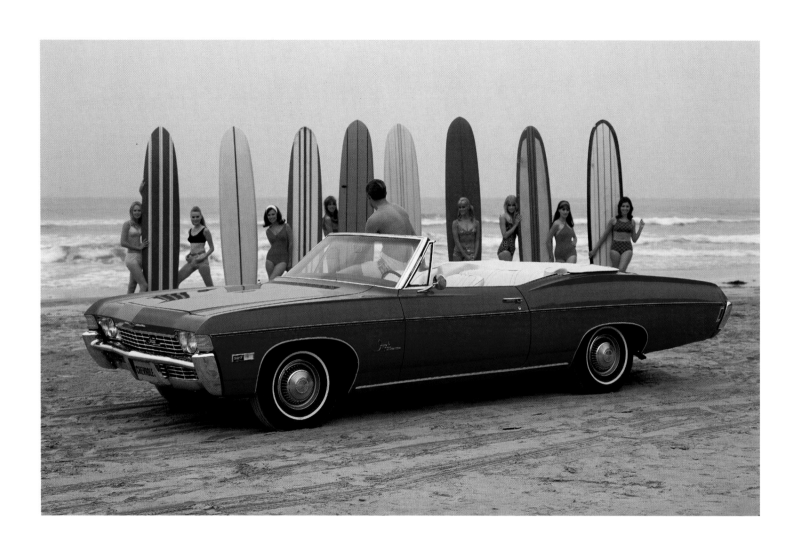

(17) 1968 Chevrolet Impala

Vern Hammarlund

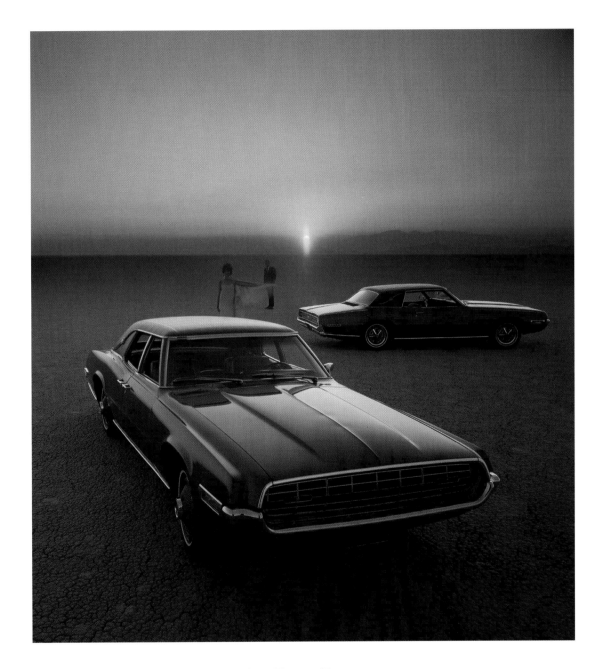

(18) 1968 Ford Thunderbird

Mickey McGuire and Jimmy Northmore, Boulevard Photographic, Inc.

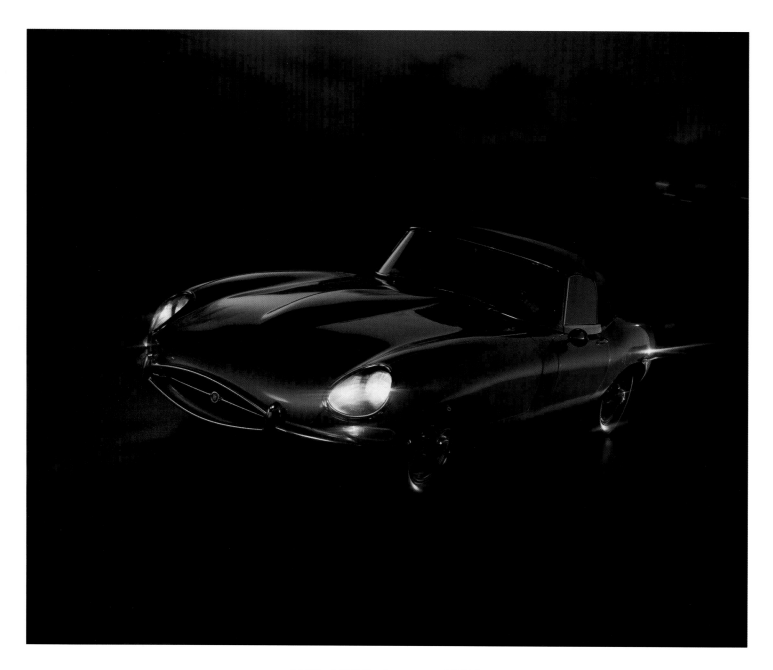

(19) 1968 Jaguar XKE

Mickey McGuire and Jimmy Northmore, Boulevard Photographic, Inc.

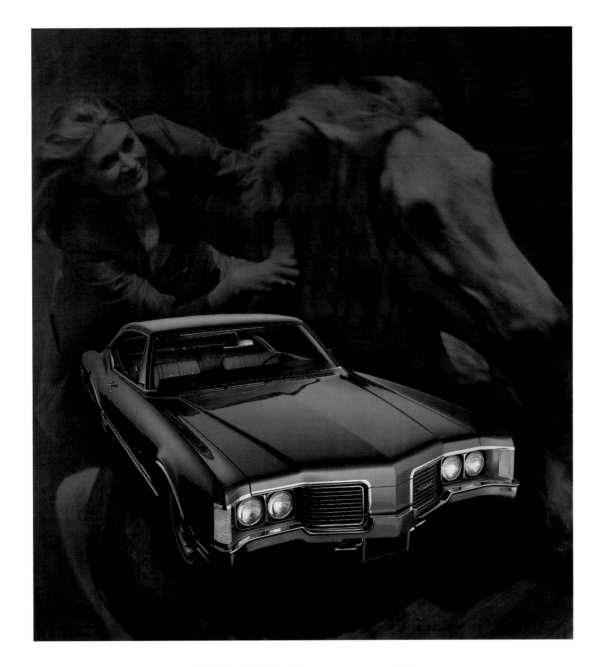

(20) 1968 Oldsmobile 88

Mickey McGuire and Jimmy Northmore, Boulevard Photographic, Inc.

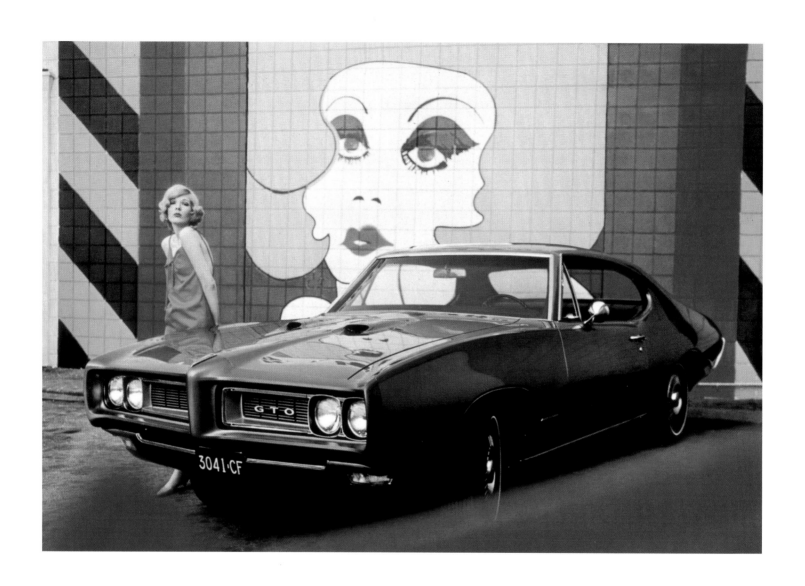

(21) 1968 Pontiac GTO

Dennis Gripentrog

(22) 1969 Chevrolet Corvette Stingray

Mickey McGuire and Jimmy Northmore, Boulevard Photographic, Inc.

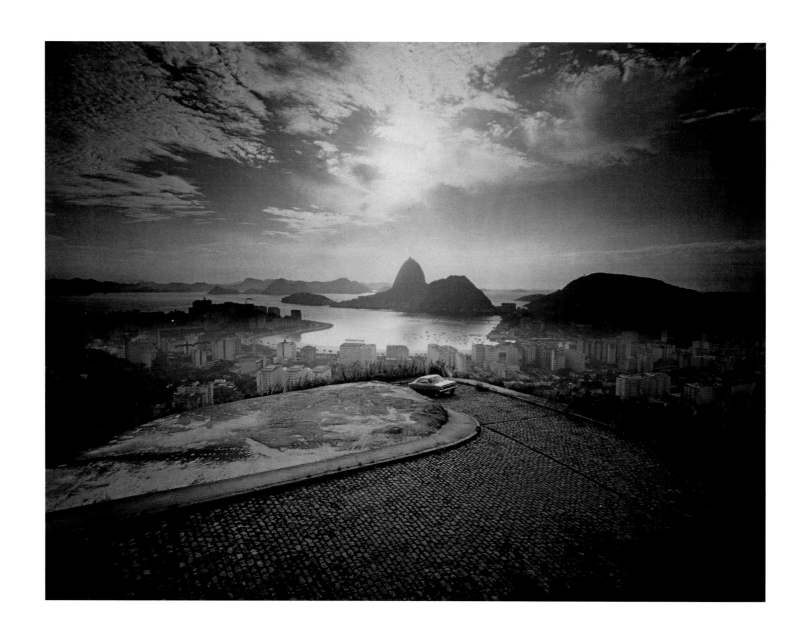

(23) 1969 Opel

Warren O. Winstanley

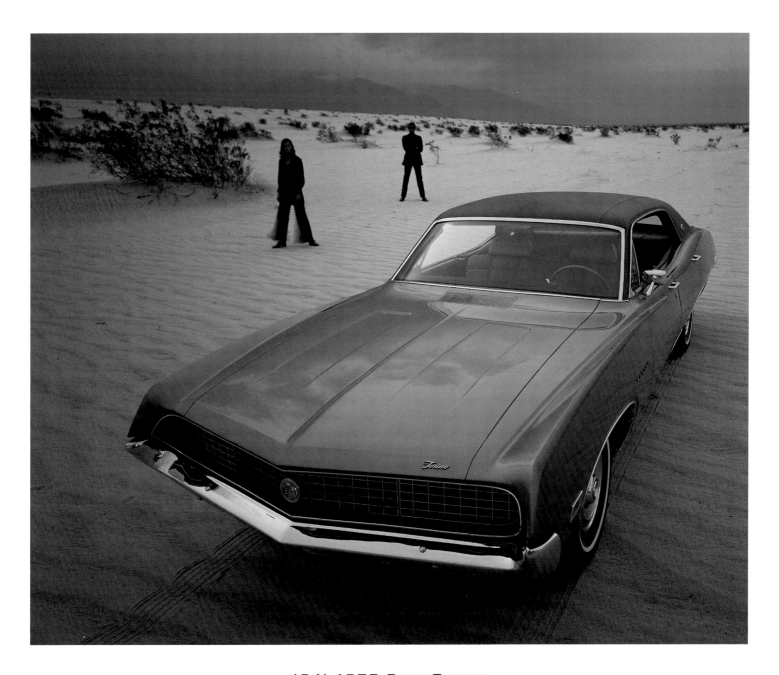

(24) 1970 Ford Torino

Mickey McGuire and Jimmy Northmore, Boulevard Photographic, Inc.

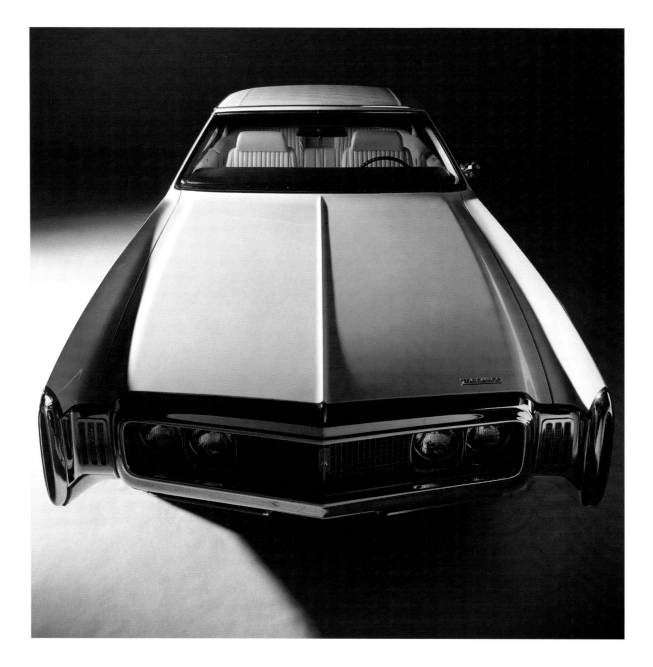

(25) 1970 OLDSMOBILE TORONADO

Vern Hammarlund

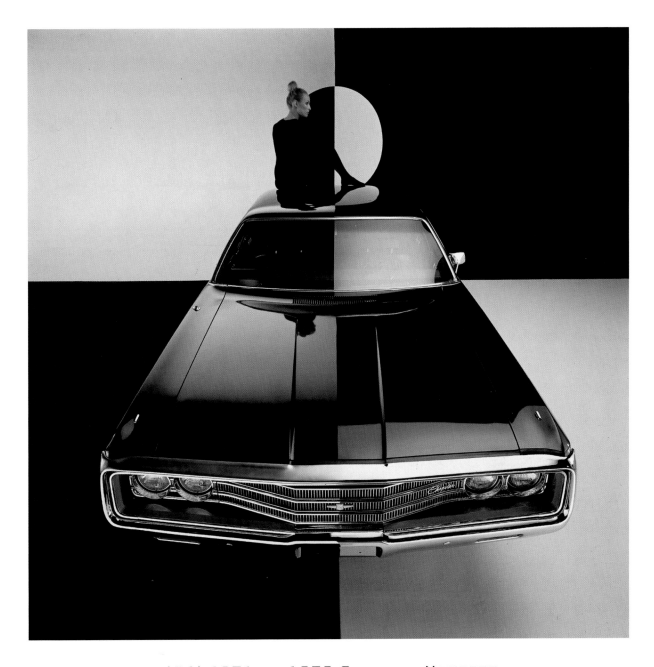

(26) 1971 OR 1972 CHRYSLER NEWPORT

Mickey McGuire and Jimmy Northmore, Boulevard Photographic, Inc.

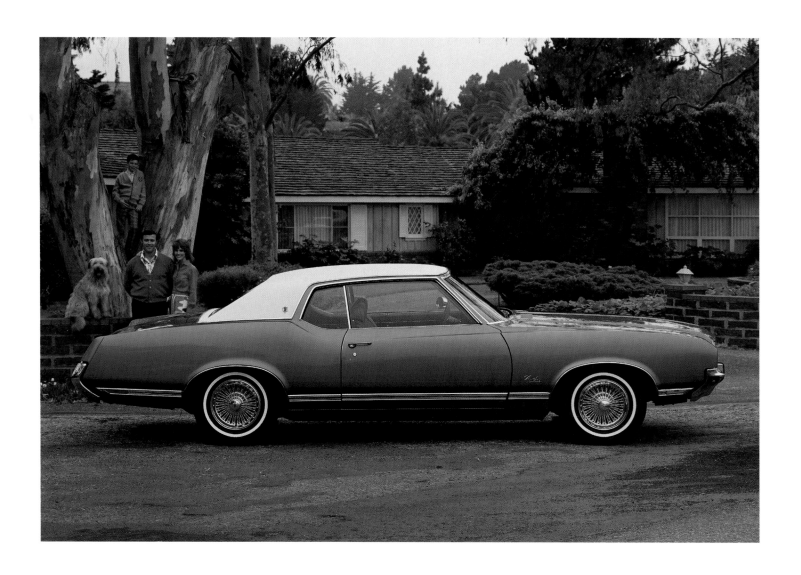

(27) 1971 Oldsmobile Cutlass

Vern Hammarlund

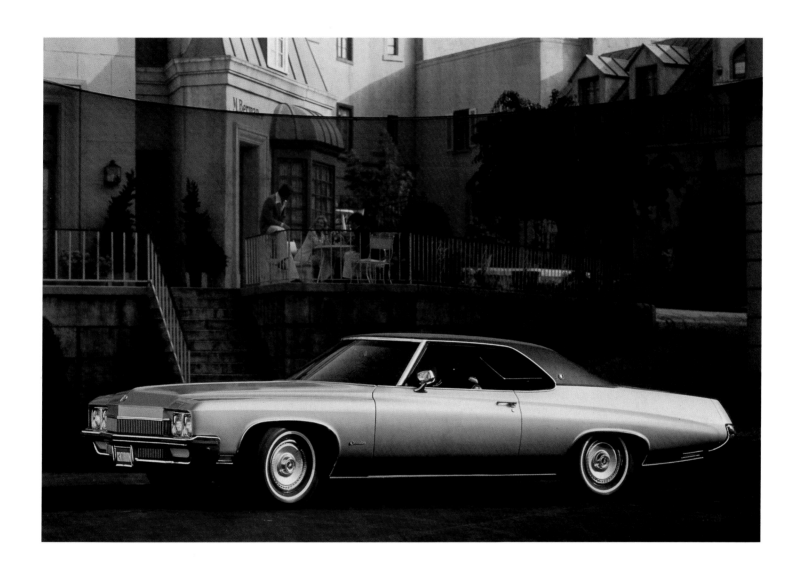

(28) 1972 Buick Centurion

Warren O. Winstanley

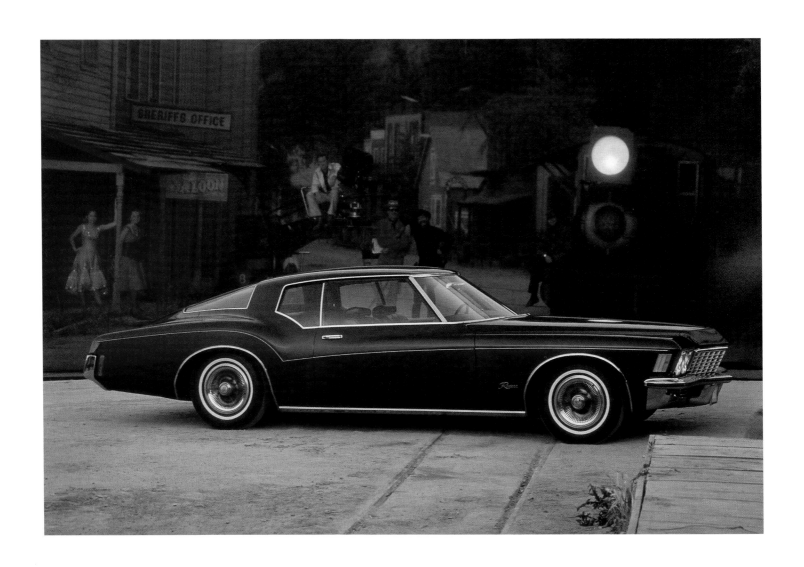

(29) 1972 Buick Riviera

Warren O. Winstanley

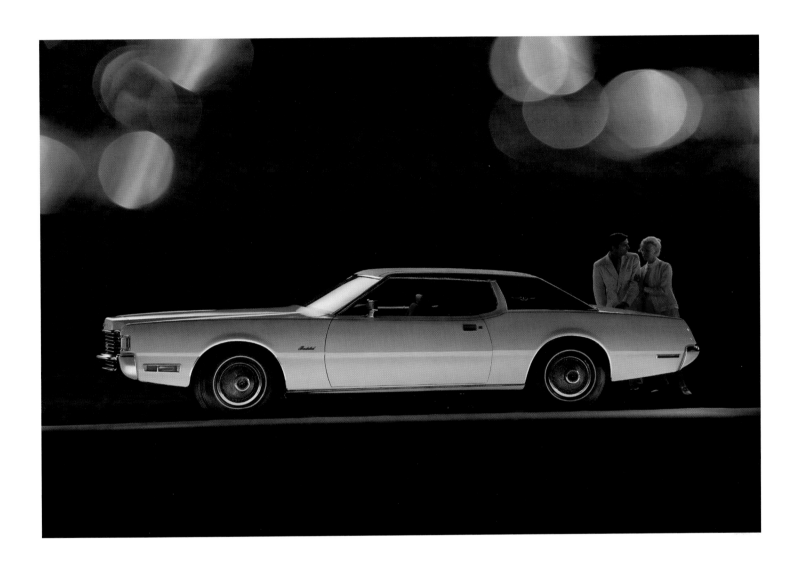

(30) 1972 Ford Thunderbird

Guy Morrison

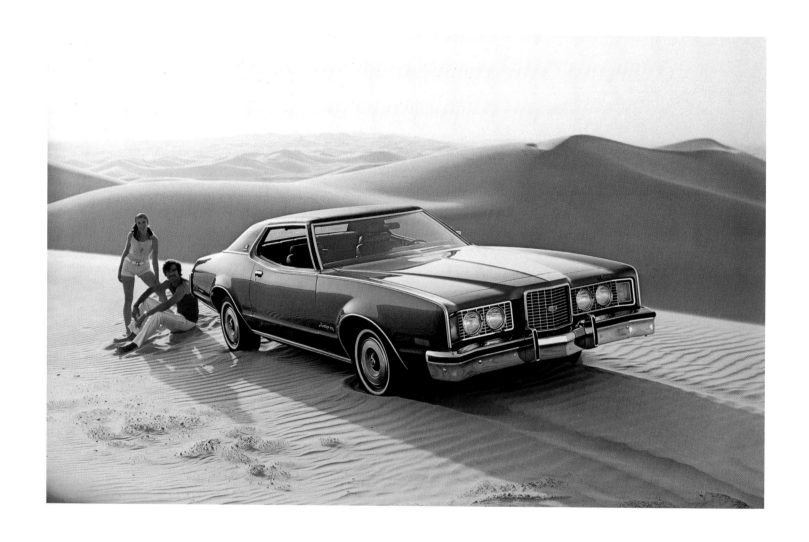

(31) 1973 MERCURY MONTEGO MX BROUGHAM

Dennis Gripentrog

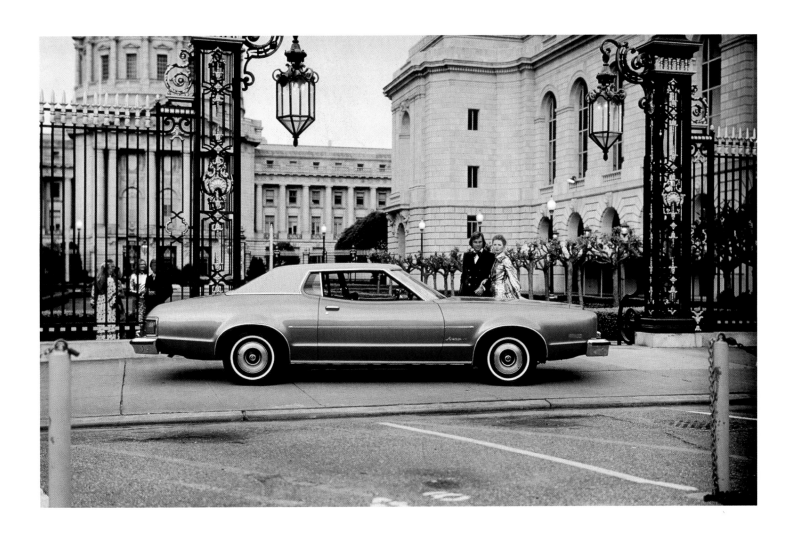

(32) 1974 MERCURY MONTEGO MX

Dennis Gripentrog

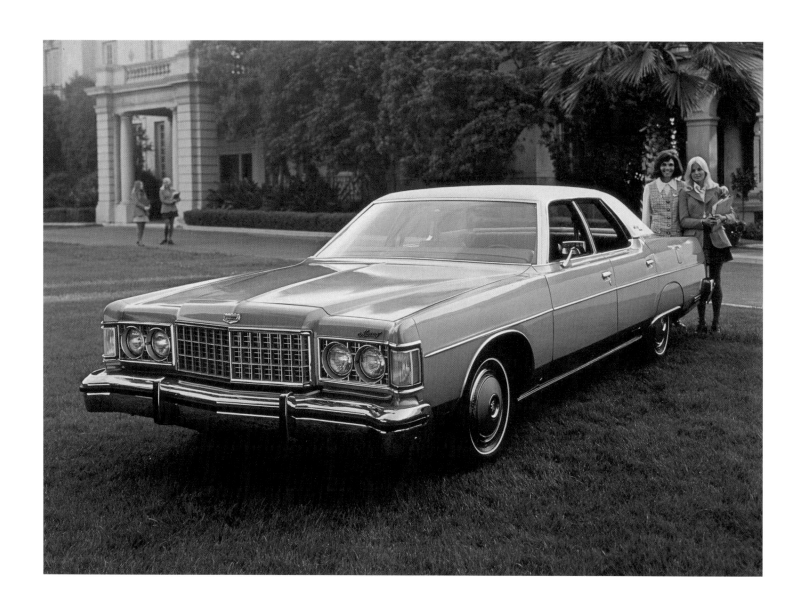

(33) 1974 Mercury Monterey Custom

Dennis Gripentrog

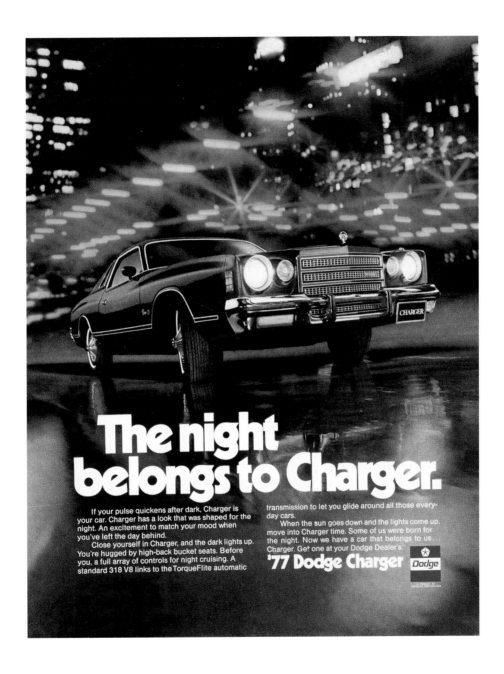

(34) 1977 Dodge Charger

Mickey McGuire and Jimmy Northmore, Boulevard Photographic, Inc.

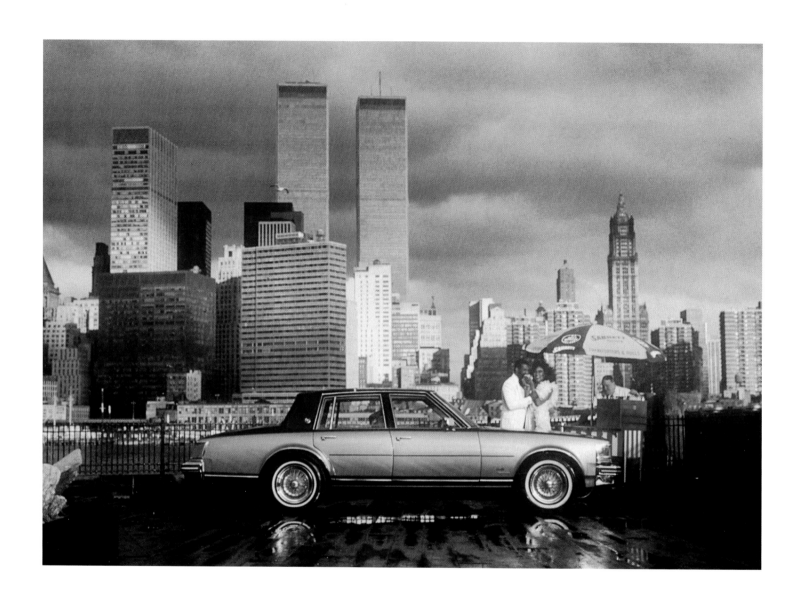

(35) 1979 CADILLAC SEVILLE ELEGANTE

Dennis Gripentrog

72

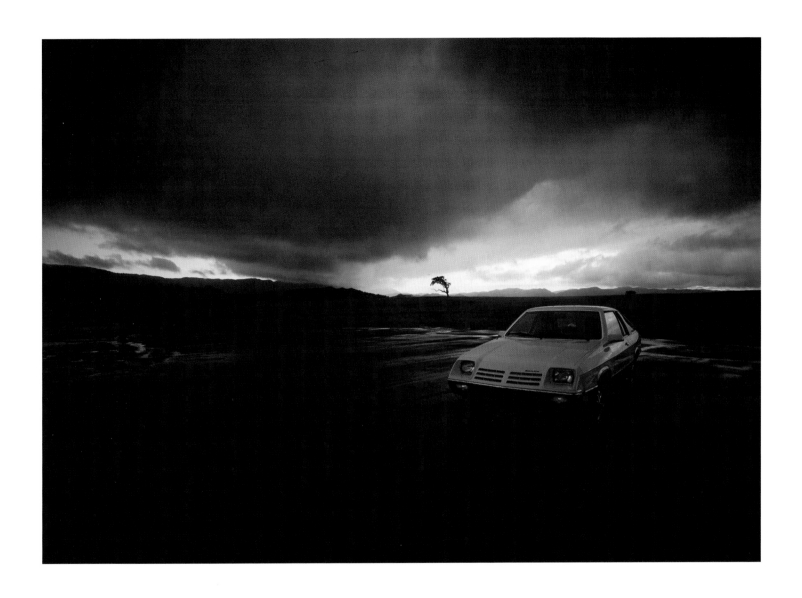

(36) Early 1980s Dodge Omni 024

Guy Morrison

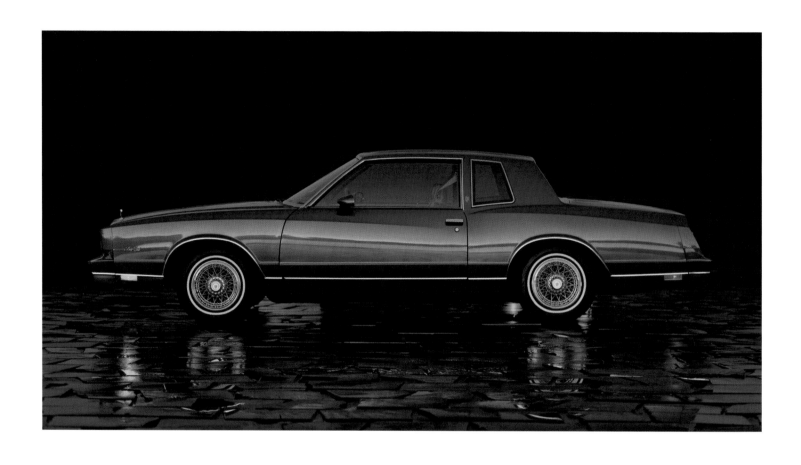

(37) MID-1980S CHEVROLET MONTE CARLO

Guy Morrison

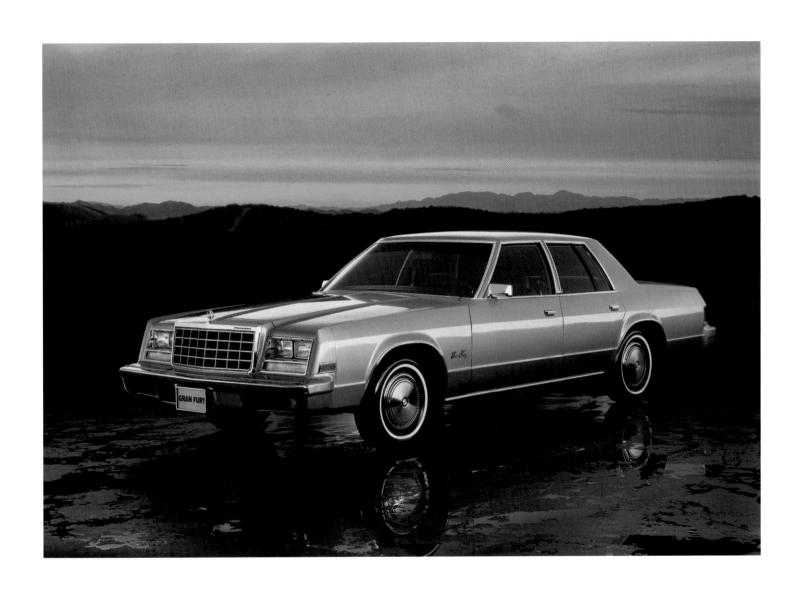

(38) 1980 PLYMOUTH GRAN FURY

Guy Morrison

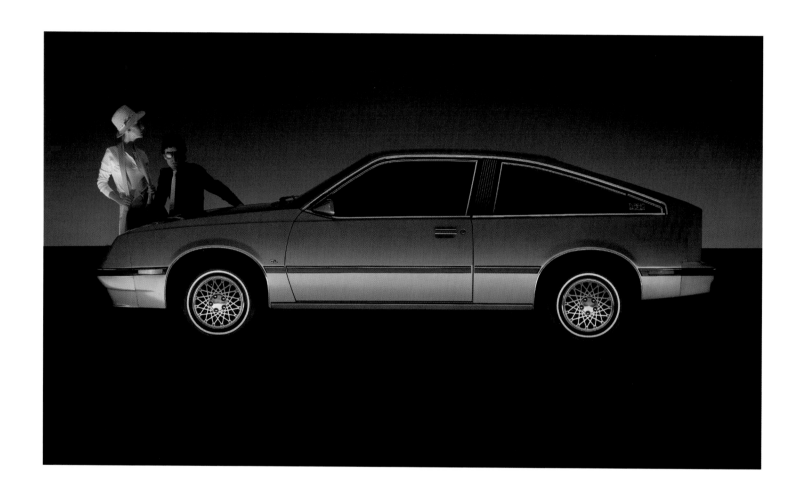

(39) 1983 CHEVROLET CAVALIER

Guy Morrison

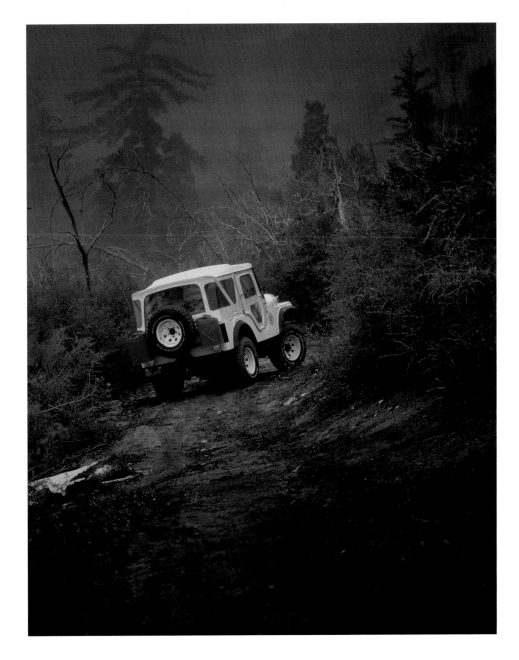

(40) 1985 JEEP

Ken Stidwill

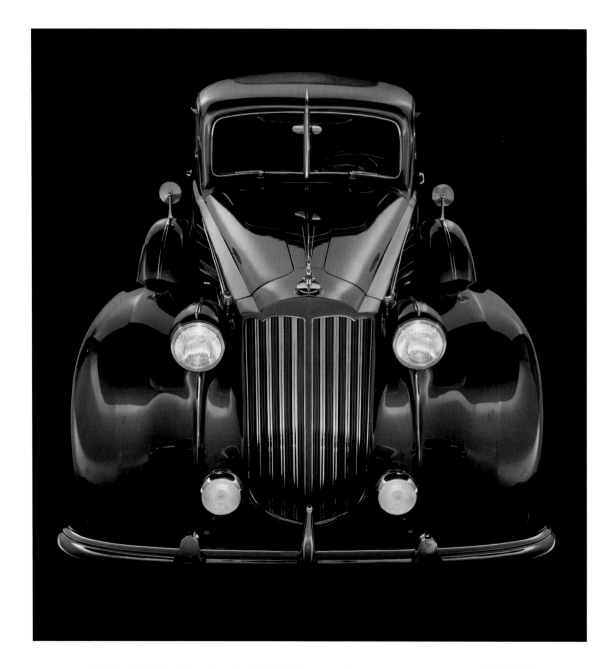

(41) 1939 Packard V-12 Coupe (photographed 1985)

Robert Traniello

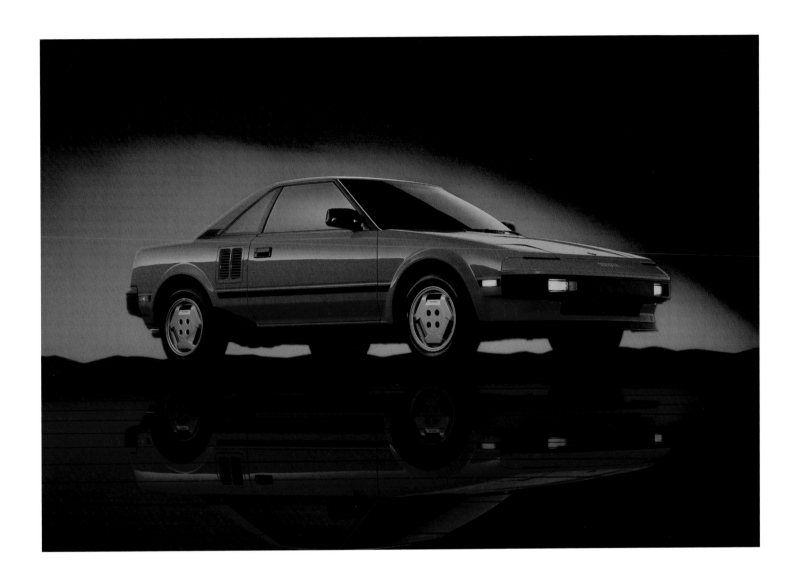

(42) 1985 Toyota MR2

Robert Traniello

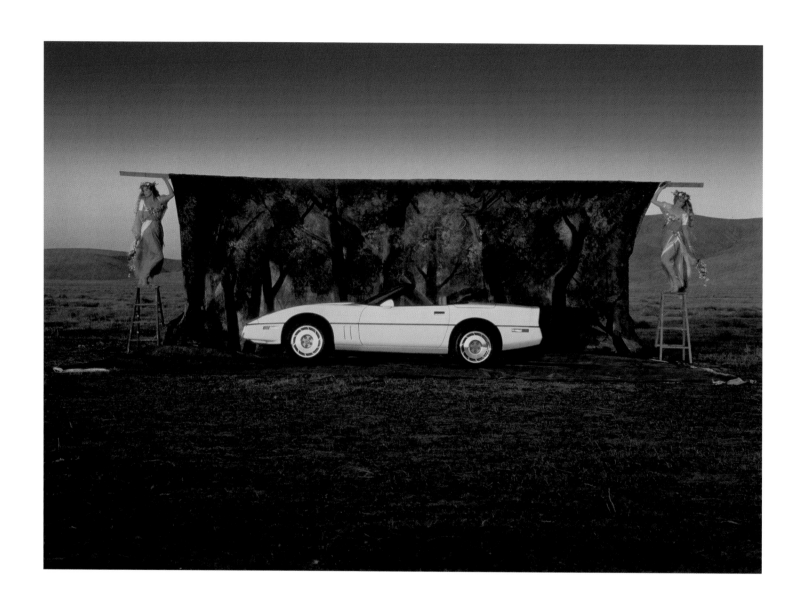

(43) 1986 OR 1987 CHEVROLET CORVETTE

Peggy Day

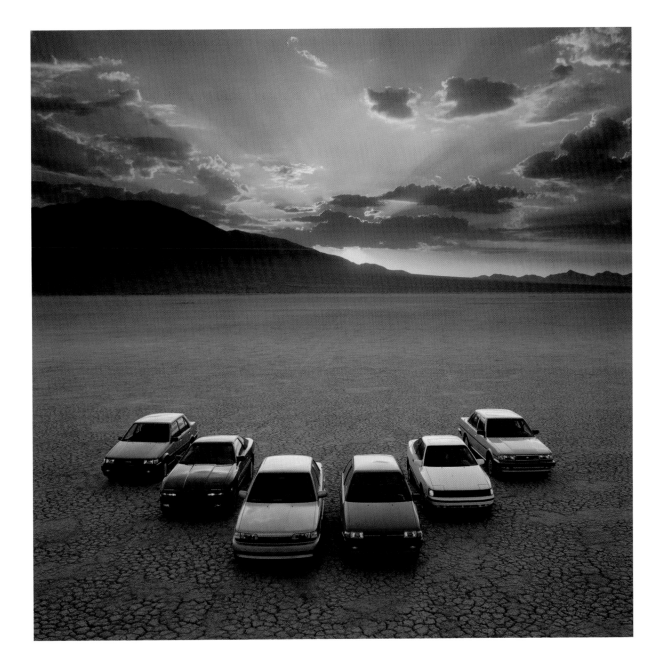

(44) 1986 Toyotas

Robert Traniello

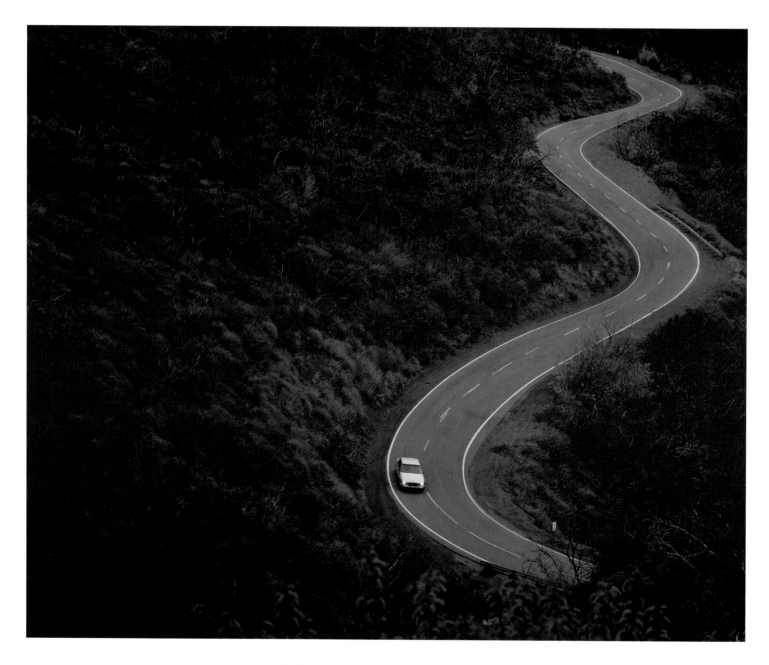

(45) 1989 BUICK RIVIERA

Thomas A. Burkhart

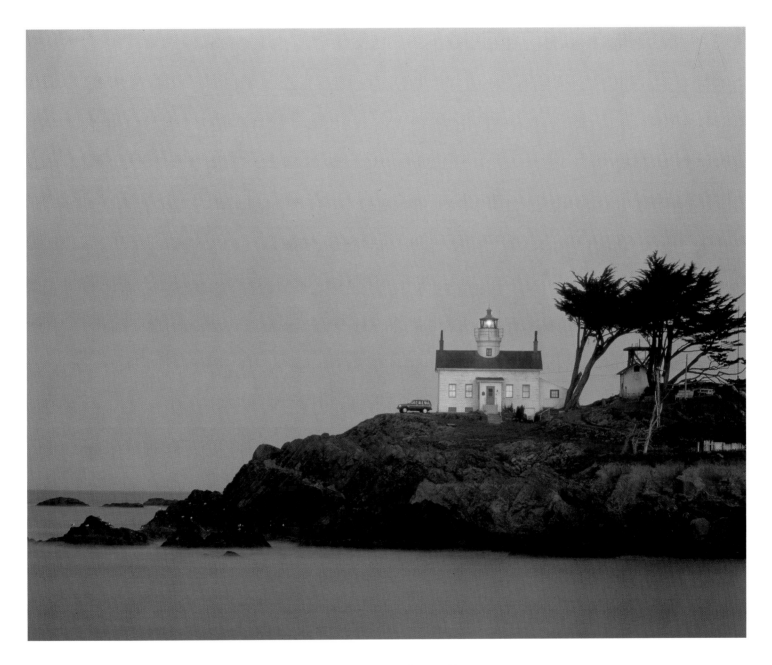

(46) EARLY 1990s JEEP CHEROKEE

Thomas A. Burkhart

(47) 1991 Chevrolet Cavalier

Dennis Wiand

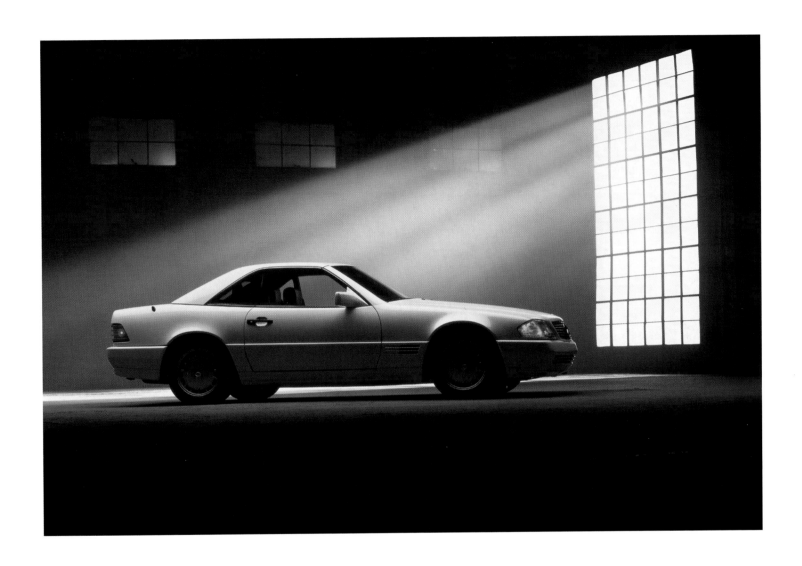

(48) 1992 Mercedes-Benz SL

Thomas A. Burkhart

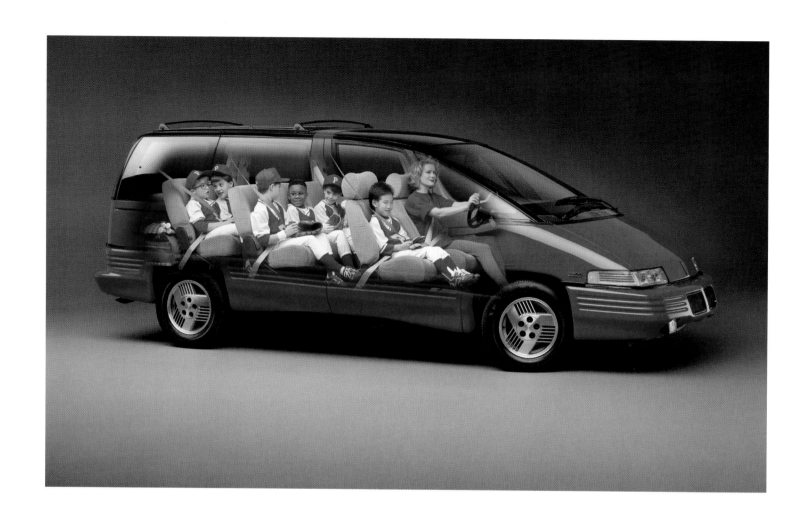

(49) 1992 or 1993 Pontiac Trans Sport

Dennis Wiand

(50) 1941 Buick Special Sedanette (Model 46S) (photographed 1993)

Steve Cooper

(51) 1993 Jeep Cherokee

Dennis Wiand

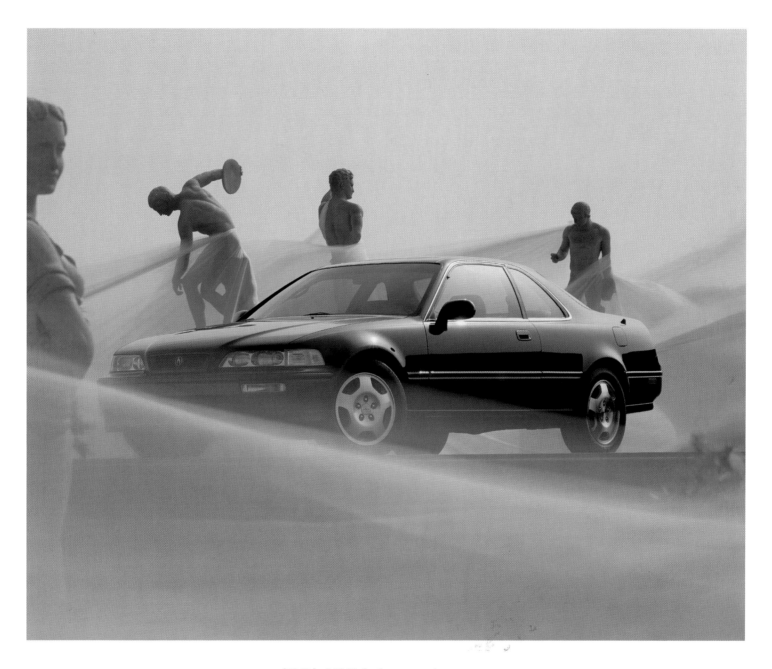

(52) 1994 ACURA LEGEND

Peggy Day

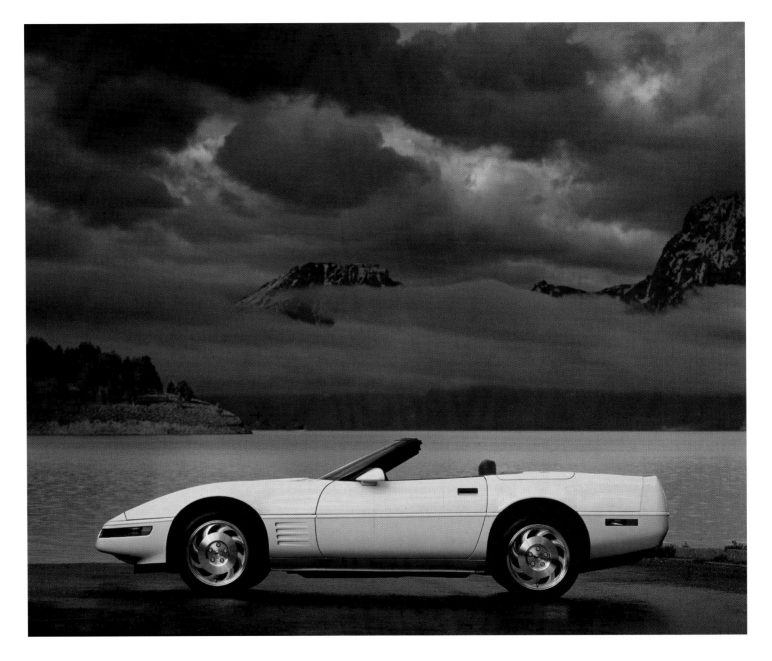

(53) 1994 CHEVROLET CORVETTE

Ken Stidwill

(54) 1994 Chrysler New Yorker

Ken Stidwill

(55) 1996 Mercedes-Benz

Tim Damon

CHECKLIST OF THE EXHIBITION

Unless otherwise indicated, photographs are chromogenic prints made for the exhibition from transparencies or other prints borrowed directly from the photographers.

ROBERT BORUM

1967 Ford Thunderbird
Gelatin silver print
Courtesy of the Ford Motor Company

THOMAS A. BURKHART

1989 Buick Riviera

Early 1990s Jeep Cherokee

1992 Mercedes-Benz SL

CLELAND CLARK

1952 Packard 200
Gelatin silver print
Courtesy of the Detroit Public Library,
National Automotive History Collection

STEVE COOPER

1941 Buick Special Sedanette (Model 46 S)
Photographed in 1993

TIM DAMON

1996 Mercedes-Benz

PEGGY DAY

1986 or 1987 Chevrolet Corvette

1994 Acura Legend

WALTER FARYNK

1955 Chevrolet Bel Air
Gelatin silver print
Courtesy of the GM Media Archives

1956 Buick Century
Gelatin silver print
Courtesy of the GM Media Archives

1958 Chevrolet Corvette
Gelatin silver print
Courtesy of the GM Media Archives

1966 Buick Riviera
Courtesy of the GM Media Archives

1967 Buick LeSabre
Courtesy of the GM Media Archives

DENNIS GRIPENTROG

1968 Pontiac GTO

1973 Mercury Montego MX Brougham

1974 Mercury Montego MX

1974 Mercury Monterey Custom

1979 Cadillac Seville Elegante

VERN HAMMARLUND

1964 Pontiac Tempest

1964 Pontiac Tempest

1968 Chevrolet Impala

1970 Oldmobile Toronado

1971 Oldsmobile Cutlass

CLIFTON HARTWELL

1950 Hudson Custom Commodore Series
Convertible Brougham
Dye transfer print
Lent by the Detroit Public Library,
National Automotive History Collection

MICKEY MCGUIRE
AND JIMMY NORTHMORE,
BOULEVARD PHOTOGRAPHIC, INC.

1954 DeSoto Firedome

1954 Packard Caribbean

1954 Packard Pacific

1955 Dodge Royal Lancer

1956 DeSoto Fireflite

1956 Ford Fairlane Sunliner

1959 Buick Electra 225

1959 Lincoln Continental

1959 Lincoln Continental

1960 Buick Invicta

1960 Dodge Polara

1961 Plymouth Fury and Advertisement
Dye transfer print
Lent by the Detroit Public Library,
National Automotive History Collection,
Northmore and McGuire Photographic Archive

1963 Cadillac Series 62 Advertisement
Lent by the Detroit Public Library,
National Automotive History Collection,
Northmore and McGuire Photographic Archive

1963 Ford Thunderbird

1964 Chrysler 300

1967 Ford Thunderbird

1968 Chevrolet Corvette Stingray

1968 Ford Thunderbird

1968 Jaguar XKE

1968 Oldsmobile 88

1968 Oldsmobile 88

1969 Chevrolet Corvette Stingray

1969 Oldsmobile Delta 88

Checklist

Boulevard Photographic, Inc. (cont'd)

1969 Oldsmobile Cutlass
Gelatin silver print
Courtesy of the Detroit Public Library, National Automotive History Collection, Northmore and McGuire Photographic Archive

1970 Ford Torino

1970 Oldsmobile 442

1970 Oldsmobile Delta 88

1971 or 1972 Chrysler Newport

1974 Dodge Monaco

1974 Dodge Monaco

1976 Ford Gran Torino

1977 Dodge Charger and Advertisement
Lent by the Detroit Public Library, National Automotive History Collection, Northmore and McGuire Photographic Archive

1979 Jaguar XJ6 Series III

Guy Morrison

1972 Ford Thunderbird

Early 1980s Dodge Omni 024

1980 Plymouth Gran Fury

Mid-1980s Chevrolet Monte Carlo

1983 Chevrolet Cavalier

Jimmy Northmore

1950 Mercury
Lent by the Detroit Public Library, National Automotive History Collection, Northmore and McGuire Photographic Archive

Ken Stidwill

1985 Jeep

1985 or 1986 Ford Mustang GT

1994 Chevrolet Corvette

1994 or 1995 Chrysler LHS

Robert Traniello

1939 Packard V-12 Coupe
Photographed in 1985

1985 Toyota MR2

1986 Toyotas

Dennis Wiand

1991 Chevrolet Cavalier

1992 or 1993 Pontiac Trans Sport

1993 Jeep Cherokee

Warren O. Winstanley

1962 Ford Galaxie
Courtesy of John Winstanley Studio 1931

1963 Chrysler New Yorker Advertisement
Courtesy of John Winstanley Studio 1931

1963 Pontiac Grand Prix Advertisement
Courtesy of John Winstanley Studio 1931

1967 Mercury Marquis Advertisement
Courtesy of John Winstanley Studio 1931

1969 Opel
Courtesy of John Winstanley Studio 1931

1972 Buick Centurion
Courtesy of John Winstanley Studio 1931

1972 Buick Centurion Sales Catalog
Lent by John Winstanley Studio 1931

1972 Buick Riviera
Courtesy of John Winstanley Studio 1931

Equipment

8 x 10 inch Deardorff
Lent by Robert Vigiletti

Film holder with curved plane
Lent by Boulevard Photographic Inc.

Anamorphic lens
Lent by Guy Morrison

Hypergon lens
Lent by Thomas A. Burkhart

Additional Catalogue Photo Credits

Figs. 1, 4, 9, 10, 11, 12, 13: *Detroit Public Library, National Automotive History Collection.* Unless otherwise noted, all plates provided by the photographers. Plates 1, 3: *Detroit Public Library, National Automotive History Collection.* Plates 2, 10, 34: *Detroit Public Library, National Automotive History Collection, Northmore and McGuire Photographic Archive.* Plates 5, 6, 7, 14, 15: ©*General Motors Corp., used with permission.* Plate 16: *Courtesy of Ford Motor Company.* Plates 23, 28, 29, and back cover: *Courtesy of John Winstanley Studio 1931.*

INDEX

Numbers refer to text-page numbers, not to catalogue numbers. Numbers in boldface are illustration-related references.

INDEX